NILE

The Promise Written in Sand

NILE

The Promise Written in Sand

Bonnie Gaunt

Adventures Unlimited Press
Kempton, Illinois 60946, U.S.A.

Copyright © 2005 Bonnie Gaunt

Adventures Unlimited Press
P.O. Box 74
Kempton, IL 60946 U.S.A.
auphq@frontiernet.net
www.adventuresunlimitedpress.com

Manufactured in the United States of America

ISBN 1-931882-41-X

Hebrew Gematria is based on the Masoretic Text
Greek Gematria is based on the Nestle Text

Cover art by Adventures with Nature, East Lansing, MI

Contents

Foreword

The source of the Nile is an ancient mystery that has been solved – or so they say. Yet its mysteries are still being investigated and magnificent discoveries are being made.

In the mid 1800s the search for the source of the mighty Nile was the subject of world-wide interest and excitement, even involving the rivalry of nations. Why has this one river stirred the passions of so many?

The land of Egypt, without the flow of the Nile, would be a lifeless desert where no rain falls. This is why, from ancient times, men wondered what could possibly be the source of this mighty abundance of water, since no rain fell to feed its flow. Many theories were proposed, and many lives were lost in the pursuit of its secrets. And even today, with the aid of global positioning satellites, the mystery still persists.

When I began this study several years ago, I had no idea I would stumble upon the amazing evidence that I have now attempted to share in this book. This magnificent river tells a story that includes you and me, and the destiny of the entire human race. It was encoded there in the world's longest river even before the creation of man.

I did not embark upon this investigation alone. There have been many who have been drawn to the mysteries of this magnificent river. Some have recorded the histories of the search for the source, and the lives of those dedicated men who endured such personal hardship in its pursuit. Some have seen deeper, and sensed a spiritual significance may be sought. Even Dr. David Livingstone, who gave his life in search of the source, felt this river had taken on spiritual overtones. It had become a vital part of his relationship with God. And indeed this river is a testimony to the very existence of that God.

I wish to thank all who have encouraged me in the pursuit of understanding, and especially Ronald M. Prosken, without whose help this book would never have become a reality. Our many and continued discussions and research are a vital part of this work.

And my utmost praise and thanks goes up to a magnificent God who planned from the beginning, and has gradually been revealing this awesome plan for His human family, whom He loves. That plan is encoded in the flow of the river.

Bonnie Gaunt, 2005
Mountain Home, Arkansas, U.S.A.

Hebrew and Greek Gematria

		Gematria Value	Place Value			Gematria Value
Aleph	א	1	1	Alpha	α	1
Beth	ב	2	2	Beta	β	2
Gimel	ג	3	3	Gamma	γ	3
Daleth	ד	4	4	Delta	δ	4
He	ה	5	5	Epsilon	ε	5
Vav	ו	6	6	Zeta	ζ	7
Zayin	ז	7	7	Eta	η	8
Cheth	ח	8	8	Theta	θ	9
Teth	ט	9	9	Iota	ι	10
Yod	י	10	10	Kappa	κ	20
Kaph	כ ך	20	11	Lambda	λ	30
Lamed	ל	30	12	Mu	μ	40
Mem	ם מ	40	13	Nu	ν	50
Nun	נ ן	50	14	Xi	ξ	60
Camek	ס	60	15	Omicron	ο	70
Ayin	ע	70	16	Pi	π	80
Pe	פ ף	80	17	Rho	ρ	100
Tsaddy	צ ץ	90	18	Sigma	σ ς	200
Qoph	ק	100	19	Tau	τ	300
Resh	ר	200	20	Upsilon	υ	400
Shin	ש	300	21	Phi	φ	500
Tav	ת	400	22	Chi	χ	600
				Psi	ψ	700
				Omega	ω	800

There are 22 letters and 27 characters in the Hebrew Alphabet. The ancient Greek alphabet had 26 letters and 27 characters, but two letters have become obsolete.

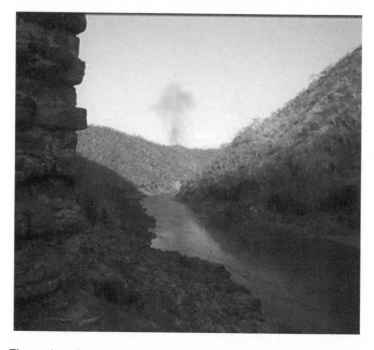

The copious flow of the Nile brings life to the barren deserts of Egypt. In a land where there is no rain, men have wondered from what source does this ample river flow. Many have given their lives in the search for its source. Dr. David Livingstone, who died in the pursuit of its "fountains," felt that finding it would be coming to the face of God.

1

The Promise

The Nile has carved its winding path through the deserts of Africa, bringing, like a promise written in sand, life to the barren land, and hope to a barren world.

It is the world's longest river.

The Nile is the only major river flowing northward. As it winds its way down from the mountains of Uganda, through the lifeless sands of Egypt, depositing its rich nutrients, it brings hope and prosperity to a thirsty land. After a descent of 4,000 feet and a flow of 4,000 miles, it plants its rich treasures at its massive delta, creating the most fertile land on our entire globe.

At the head of this largest delta in the world, the Great Pyramid stands in silent splendor, holding within its ancient stone walls the secrets of the ages.

From time immemorial, men have found their livelihood along the banks of the Nile. It is the land of the Pharaohs, the land of the Pyramids, the land of wealth and of promise. When Jacob of old brought his family to Egypt, he settled in the rich land of the Nile delta. They called it Goshen. It was here that Moses was born, and placed among the reeds along its banks. It was here that the baby Jesus was brought, to flee from the wrath of King

Herod. It is here that time, and the river flowing, brings its everlasting promise – a promise of life.

The winds of time have not erased the promise of the Nile. It is a promise indelibly etched into the sands of Egypt. Sand, we have all observed, is not a retainer of shape nor record – being easily swept away by wind and water. What an unlikely place for a promise that was to last for the ages of eternity.

It was not by chance that the river was named "Nile." Its Hebrew spelling is נחל, (pronounced *ncheel*) which has a number equivalent of 88.

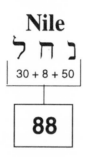

Nile

נ ח ל

| 30 + 8 + 50 |

88

The prophet Isaiah told of one who would come to bring life – one who would be represented by the number 88. He said:

Unto us a child is born, unto us a son is given: and the government shall be upon his shoulder: and his name shall be called Wonderful, Counsellor, The mighty God, The everlasting Father, The Prince of Peace. Of the increase of his government and peace there shall be no end,

upon the throne of David, and upon his king-dom, to order it, and to establish it with judg-ment and with justice from henceforth even for ever." (Isaiah 9:6-7)

The identification of this One who would bring life was *"a child is born."* This has a number value of 88 in the original Hebrew text.

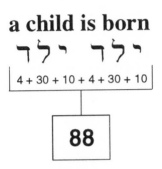

This is not just a chance encounter with the number 88. Approximately 800 years after Isaiah wrote this prophecy of one who would come as a child, the angel Gabriel announced to a young Hebrew girl that she would have a son and that she should name him Jesus. This name, as it appears in the original text of the New Testament, has a number value of 888.

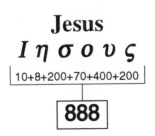

The Nile flows from the clear waters of Lake Victoria, descending 4,000 feet and flowing 4,000 miles to the Great Pyramid at the head of the delta, from where it fans out into a quadrant of a circle, once cut into seven streams, depositing its nutrients into the most fertile land on the face of the earth.

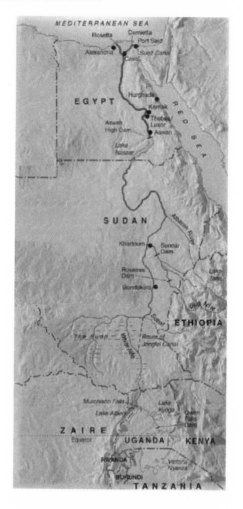

From the beginning of the creation of man, Jesus Christ was the foretold *"Lamb slain from the foundation of the world."* Four thousand years after Adam fell from the perfection in which he was created, Jesus came to earth to pay the price for Adam's sin. The Promise of the Nile begins to unfold.

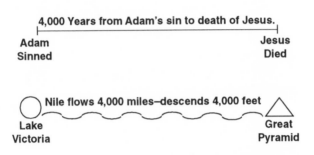

Lake Victoria, from which this mighty river flows, was officially named in 1857 by John Hanning Speke, in honor of his queen, Victoria. Little did he realize that this vast body of water, which he so appropriately named, indeed represents "victory" – the victory over death that was purchased for man, even before it was needed. It was victory, purchased by the One who bears the number 88.

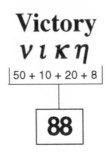

Because of this victory, purchased for man long before creation, we now have the assurance that the ultimate destination of man is LIFE. The Nile, having its beginning in Lake Victoria, becomes, both literally and symbolically a river of life – life through the redemptive work of Jesus Christ. This is the Promise.

As this magnificent river of life – this river of time – wends its way northward to the great sea, the Mediterranean, it defines the Bible's story of the fall, redemption, and restoration of man. As it cuts its way through the arid deserts of Egypt it brings life and refreshment to all who are watered by its abundance. It is, in fact, the only source of life throughth the barren sands of Egypt.

This Promise, written in sand, begins as rain falling from above – indeed, showers of blessing, bringing hope to a dying world. It is a Promise of a plan for the redemption of man, and for his ultimate reconciliation to his Maker – a magnificent plan, set in motion by a few drops of water.

2

A Few Drops of Water

All rivers begin with a few drops of water. But Lake Victoria is unique in that 85 percent of its water comes from rain falling on its surface. The remaining 15 percent is received from tributaries originating in the highlands above the lake. Its large surface area, combined with its relatively shallow depth makes rain a special source for this lake alone. Its waters come down from above.

The volume of water cradled into this shallow basin is 729 trillion gallons. As a place of beginning, the number holds significance. ($9 \times 9 \times 9 = 729$) As has been noted in many of my earlier books, the number 9 represents wholeness, completion, fulfillment and finality. It depicts the Almighty Creator in the beginning, before His works of creation, as well as the completion of His plan for the salvation and restoration of man. The Bible's first words, *"In the beginning God,"* have a number equivalent of 999. These three nines, when multiplied, define the volume of water in Lake Victoria, the place of victory purchased for man from the beginning.

The quest for the source of the Nile has been an ongoing pursuit since the days of Herodotus in the 5th century B.C. His search was a short one, attempting to

travel up the Nile from Cairo, and ending at the first impassable waterfall. However, he would later theorize that the mighty river flowed from some great fountain. Later, in the second century A.D., Ptolemy suggested that the source was in the theoretical "Mountains of the Moon." Some have even suggested that so mighty a river could have no other source than from above. The ancient philosopher, Homer, suggested that the Nile flowed from "Egypt's heaven-descending spring." And in the eighteenth century A.D., French author Montesquieu wrote, "It is not given to us mortals to see the Nile feeble at its Source." An allusion to its having a Divine beginning.

Now, in the age of satellite photography and global positioning, it has been suggested that the mystery is solved. Satellite imaging has shown that the Nile bubbles from a little spring high in the mountains of Burundi, halfway between Lake Tanganyika and Lake Victoria. Or does it?

Montesquieu spoke words of wisdom when he suggested that it was not for man to see the mighty Nile "feeble at its source." No, it is indeed not feeble at its source. Its true source is drops of water falling from above, be they one or two, or hundreds of millions. Eighty-five percent of the water in Lake Victoria comes from rain falling on its vast surface.

> *"Every good gift and every perfect gift is from above, and cometh down from the Father of lights, with whom is no variableness, neither shadow of turning."* (James 1:17)

Lake Victoria is a picture of the greatest gift ever given. The gift of life. This gift was from the *"Father of lights,"* who gave his most precious possession – His only begotten Son, Jesus Christ.

> *"For God so loved the world that he gave his only begotten son, that whosoever believeth in him should not perish, but have everlasting life. For God sent not his Son into the world to condemn the world; but that the world through him might be saved."* (John 3:16-17)

Lake Victoria is positioned exactly on the equator – the sun's closest proximity to earth. The gift is from the *"Father of lights."*

Most of the lakes in this east-central region of Africa were formed by the Great Rift. But not so Lake Victoria.

The Great Rift has its upper extremes in Syria and Lebanon, coming down through the Jordan valley, the Dead Sea, and the Gulf of Aqaba. It continues down into the trough of the Red Sea, and its southern end branches into the Gulf of Aden. However, the main section of the Rift Valley continues from the Red Sea southwest across Ethiopia and south across Kenya, Tanzania, and Malawi to the lower Zambezi River in Mozambique.

There is a western branch to the Great Rift Valley in which are a chain of lakes, the largest of which are Kioga and Albert. Through these lakes the Victoria Nile plunges in its downward course to an inpenetrable swamp land known as the Sudd.

Lake Victoria, however, is not located in the Great

Rift Valley. It is situated on a high plateau which divides the eastern from the western sections of the Rift. Water leaving the lake plunges over the escarpment in a dramatic cataract known as Ripon Falls. In 1954 Owen Falls Dam was completed, submerging the falls. But the river flows into the Great Rift. Could that Rift have been placed there by the Creator to picture the great rift that would separate sinful man from the condition of "sonship" which he originally enjoyed with his Maker?

Lake Victoria, situated at the equator, 4,000 feet above the elevation of the Great Pyramid, is not a part of the Great Rift Valley; however, the water that flows from this giant natural reservoir plunges into the Great Rift as the Victoria Nile, downstream to become the White Nile, and yet further downstream to be joined by the fertile waters of the Blue Nile. Still further downstream, it passes the Great Pyramid as its waters divide into the great Delta – the most fertile land on our planet.

The Nile is a "river of life" to the land of Egypt. Nearly all (95%) of the population of Egypt lives within twelve miles of the river. Without the Nile, Egypt would be an uninhabitable arid desert. Lake Victoria wonderfully pictures the gift of life through Jesus Christ. The Nile flowing from that high plateau, down into the Great Rift, brings life to a barren land.

The location of the source of the Nile has been the mystery of many centuries. The middle of the nineteenth century saw the most dramatic search for the source.

3

The Search for the Source

For as long as man has lived along the banks of the Nile, they have longed to solve the great mystery of the location of its source. Many have given their lives in its pursuit. The source of no other river has received so much attention.

The search for the source was the passion of the middle nineteenth century A.D., particularly in Britain and America. It fanned the fuel of an already heated rivalry between those two nations, and became a factor in the ascendency of America in world importance. The seeds, however, were planted more than two millennia earlier.

About 460 B.C. the great historian Herodotus set out to find the true source of the Nile. His efforts were short lived. The first cataract at what is now Aswan was as far as he could go. Herodutus, however, had a theory that persisted down through time, and was the compelling force of renowned Dr. David Livingstone in his search during the middle nineteenth century A.D. The theory was that the Nile sprang from four great fountains of bottomless depth at the foot of high mountains somewhere in the center of Africa.

Although his fountains and "Mountains of the Moon" were never found, Herodotus however made a true assessment of the importance of the Nile. He said "Egypt is the gift of the Nile." Indeed, the civilizations that flourished in Egypt for thousands of years could only exist because of the abundant flow of the Nile. It is truly a river of life.

According to legend, a man named Diogenes, a Greek merchant in the first century A.D., landed his sea vessel on the coast of Africa and journeyed twenty five days into the interior where he found two great lakes and a mountain range. It added fuel to the legends but did not find the source of the river.

A century later, the great geographer and astronomer, Ptolemy, produced a map showing the course of the Nile from the equator to the Mediterranean, making it to rise from two round lakes supplied by water flowing from the *Lunae Montes,* or Mountains of the Moon. For centuries, his map was the subject of dispute and speculation.

Rome's emporer Nero sent an expedition into what is now the Sudan, in an unsuccessful attempt to find the source of the Nile. The way was blocked by impenetrable swamps.

Ptolemy's map continued to be an item of curiosity and dispute. It was the compelling force that, in 1856, led two explorers, Richard Francis Burton and John Hanning Speke into central east Africa to settle the matter once and for all, and find the source of the Nile.

On June 16, 1857 the two explorers, partially funded

by Britain's Royal Geographical Society, began their journey from Zanzibar to the mainland of Africa. Their port of entry and the beginning of their trek inland was at Bagamoyo, a lovely place of coconut palms and refreshing breezes from the sea. They had chosen an overland route to the interior rather than travel south up the Nile as others before them had attempted, and failed.

A direct route was not considered safe, because of hostile tribes. Hostilities among the native people is understandable when we realize that the other nations of the world, and principally the Arabs, had for many hundreds of years been raiding tribal villages and taking the able men as slaves and the women as concubines. Africa and the slave trade had become synonymous. Thus outsiders who intruded into the interior were considered an enemy, and were fair game for stealing, looting and killing. It was a land and a time of every man being a law unto himself. Fairness, integrity and morals were not to be found; rather cannibalism, brutality, and thievery were the order of the day. Burton and Speke knew the rules of the trail, and thus avoided confrontation where possible, even though it meant many hundreds of extra miles in a circuitous route.

Where possible, they followed the beaten paths from one village to another (friendly villages no doubt), and often passed other caravans coming to the coast with an entourage of slaves, tied with chains.

Forward progress was slow. And even though they started the day at 4 a.m., while it was still dark, the

process of preparing their large caravan was arduous, and actual miles traveled in one day was not more than ten, and often less.

There were often seemingly impenetrable swamps where travel was waist-deep in muddy water, slime, tangled vegetation; and of course, infested with crocodiles, poisonous snakes, and a menagerie of other unfriendly creatures. And these, along with the myriads of insects, promoted the many illnesses that plagued them – malaria, dysentery, smallpox – to say nothing of 100-plus temperatures.

Finally, on February 13, 1858, they came in sight of Lake Tanganyika. A beautiful sight for the weary travelers. Burton suggested they circumnavigate the lake in search of a river flowing north, which, he thought, would be the source of the Nile. However, they found the Rusizi, which flows south. They were obviously on the south side of a divide. The source of the Nile lay to the north.

In their disappointment they returned to Ujiji, a town on the shores of Lake Tanganyika. There they waited for more supplies to reach them. A dispute arose between Burton and Speke regarding what route they should take. Speke had heard rumors that a large lake lay about three weeks to the north. He wanted to investigate. Burton would have none of it. He did, however agree to let Speke go, with the portion of the caravan and supplies that he needed. On July 9, 1858, Speke set off toward the north, following the hunch that the source of the Nile was in the mountains ahead of him.

As he traveled north, into the high country, the vegetation was sparse. Great boulders lay all around, and the scrub trees appeared to struggle for existence. However, as they traveled north, the vegetation began gradually to change. They could feel it in the air. This feeling of approaching a new frontier became ever more alert in their senses. The earth grew greener, and the air more humid. They found themselves surrounded by shady trees, palms, mangoes and colorful blossoming trees.

On the morning of August 3, 1858, Speke saw his first glimpse of the lake through the trees. He stood transfixed on the shore, his eyes taking in the vast seemingly limitless expanse of the lake. Of that moment, he wrote:

> I no longer felt any doubt that the lake at my feet gave birth to that interesting river, the source of which has been the subject of so much speculation, and the object of so many explorers. The Arabs' tale was proved to the letter. This is a far more extensive lake than Tanganyika, so broad that you could not see across it, and so long that nobody knew its length.

It was an astonishing and reckless conclusion to jump to. Quite frankly, Speke was guessing. He had not investigated the flow north from the lake, but he knew that a river as mighty as the Nile must have such a source.

He spent only three days at the lake, and hurried back to tell Burton the exciting news. Burton would have none of it.

Burton would later write in his journals of his dis-

gust with Speke's insistence that he had found the source of the Nile.

> We had scarcely breakfasted before he announced to me the startling fact that he had discovered the sources of the White Nile.... After a few days it became evident to me that not a word could be uttered on the subject of the Lake, the Nile, and his *trouvaille* generally without offence. By tacit agreement it was, therefore, avoided, and I should never have resumed it had my companion not stultified the results of the Expedition by putting forth a claim which no geographer can admit, and which is at the same time so weak and flimsy that no geographer has yet taken the trouble to contradict it.

Speke, however, wrote in his journal his own observations of the situation:

> I expressed my regret that he did not accompany me as I felt quite certain in my mind that I had discovered the source of the Nile. This he naturally objected to, even after hearing all my reasons for saying so, and therefore the subject was dropped. Nevertheless the Captain accepted all my geography leading from Kazeh to the lake, and wrote it down in his book–contracting only my distances, which he said he thought were exaggerated, and of course taking care to sever my lake from the Nile by *his* Mountains of the Moon.

Herodotus' "Mountains of the Moon," which were later to be proven non-existent, were Burton's trump card in the dispute with Speke. He drew a map and placed these

fictional mountains squarely between the White Nile and the newly discovered Lake Victoria (which Speke had named in honor of his Queen).

The breach between the two explorers became widened with each passing day. Both were so ill physically that they had to be carried. Upon reaching the coast, they boarded a dhow for Zanzibar, only to find that an epidemic of cholera had already killed some ten thousand residents. They sailed for Aden. There Burton's illness worsened, and he was not able to accompany Speke on the journey back to England.

When Speke reached London, he immediately sought audience with Sr. Roderick Murchison, the President of the Royal Geographical Society, and of course over flowed with the great news that he had solved the great secret of the Nile, and had found its true source.

Immediately Speke was asked to give an address to the members of the RGS, during which he took full advantage of the opportunity to press his views. Within a week of his arrival in London, word got around that this modest young man had made a discovery of extraordinary importance, and he was asked to go to Africa again to head a new expedition in the interests of finding all the details and creating a new and exact map. The Royal Geographical Society quickly raised a sum of £2,500 to fund the proposed expedition.

To accompany Speke, the RGS appointed Captain James Augustus Grant, an Indian Army officer. Speke had met Grant earlier, during his army experience in India,

and they had become good friends. Soon they set sail for Africa.

The arduous trip inland took its toll on Grant, making it impossible to continue because of an infection in his leg that made walking, or even being carried, impossible. He was caused to delay for three months until he was healed sufficiently to join Speke, who by this time had reached Lake Victoria, but had been detained by a tribal king, Mutesa, who would not allow him to leave his royal court. Metusa was glorying in the privilege of having a white man in his court, and was not willing to let him go. However, while there, Speke heard talk of a wide river that poured itself out of the lake on its north side, plunging down in a great fall of water.

Grant was not fully healed of his leg wound, and so it was agreed that Speke would proceed without him. On July 21, 1862 the caravan reached the river about 40 miles downstream from the lake. Upon reaching the river, Speke knew it was the upper extremity of the White Nile. His excitement was such, upon seeing the river, that he told his men "they ought to shave their heads and bathe in the holy river, the cradle of Moses."

The caravan marched upstream, and on July 28 reached the great fall. The roar of the white water plunging into the gorge was deafening, but it was the most wonderful sound Speke had ever heard. He wrote in his journal, "It was a sight that attracted one for hours – the roar of the waters, the thousands of passenger-fish leaping at the falls with all their might...hippopotami and

crocodiles lying sleepily on the water...."

Speke, joined again by Grant, continued his journey north, following the river, circumventing the impassable swamps of the Sudd, and joining the river again at Gondokoro. Eventually they made their way downstream to Cairo where they cabled London with the news of their successful expedition.

John Hanning Speke
(© Hulton-Deutsch Collection)

The broken plaque at Jinja, Uganda – a memorial to the discovery of the source of the Nile by John Hanning Speke on July 28, 1862

The matter of the source of the Nile was not, however, settled. There was much dispute and much disbelief. Many felt Speke's claim to have found the source was audacious and unproven.

On September 16, 1864, the Royal Geographical Society and the British Association, called for an assembly in the only auditorium in town – the east wing of the Mineral Waters Hospital. Burton and Speke were to debate and settle the matter once and for all. The event came to be known as the Nile Duel.

The auditorium was filled to capacity, and the time had come for the debate to begin, but the audience waited in advancing discomfort as the time ticked on and no one came to occupy the chairs on the stage. More time passed. Finally, when it was much too late even for apologies, Sir Roderick Murchison slowly walked from the wings onto the center of the stage. In his usual convoluted manner of speaking, he slowly announced: "I have to apologize but when I explain to you the cause of my being a little late in coming to take the chair you will pardon me." He paused briefly and looked at the disgruntled audience. Then he continued: "Captain Speke has lost his life."

Speke, who had felt increasing discomfort and even anger over the coming debate, had decided to go hunting instead. He had lodged his Lancaster breech-loading rifle into a stone wall and then had attempted to climb over. In the process, the rifle was jarred, causing it to fire. Many believed it to have been a suicide. Whatever Speke may have done that afternoon, it was the final result of all his

misery in trekking through the swamps and jungles of Africa, the elation of having found the answer to the mystery of the Nile, and then not having been believed by his peers nor the public.

If the symbolic source of the Nile is Jesus Christ, as is the concept of this book, it too has been the subject of debate and disbelief. Jesus Christ, as the means of redemption for the human race, has been maligned, disbelieved, and generally not accepted by the majority of the world. Yet, its waters "from above" have come down to give life to a thirsty world, most of whom deny His existence.

Soon after Speke's death, Sir Roderick Murchison set about looking for a man who would travel into the heart of Africa and settle the matter, forever. Or so he thought. The man he chose was Dr. David Livingstone.

Livingstone had been born into a large and very poor family, and as a child had been expected to supplement the family income by working in a cotton mill. But his dreams were elsewhere. As a young teenager he would escape the din and drudgery of the cotton mill for long hikes through the countryside. But his passion was for reading books of adventure, and his dreams were of becoming a missionary in some far off land.

After putting himself through medical school, he went to London to train as a missionary. His dream was to go to China. He could combine his medical knowledge with his new-found deep religious convictions, and be of service to God and his fellow man.

But by the time he finished his studies at the semi-

nary, going to China was out of the question, because Britain and China had gone to war. As an alternate destination, he was given an assignment as a missionary in southern Africa.

At the age of twenty seven, he set off for Africa. By now he was not only a medical doctor, but also an ordained minister. And he was an idealist. His deepest desire was to follow the example of the Apostle Paul, even if it meant great hardship, and reach those people in far-flung Africa who might otherwise never have the opportunity to hear of Jesus Christ. He received permission to "go forward," he wrote, "into the dark interior." He felt this was his destiny, this is what he was made for, this is what he had trained for, and now the time had come for him to "be about his Father's business."

Livingstone traveled to places that few others had ever gone, teaching Jesus Christ to all who would listen. His penchant for exploration took him across the Kalahari Desert, and an east-to-west trek across Africa. In the process, he charted the interior of Africa. News of his explorations were published in London, and in the eyes of Britain, Livingstone was their new-found hero.

During his fifteen year experience in Africa, he had become painfully aware of the injustice of the slave trade. Upon returning to England his new-found fame gave him a forum from which he denounced the practice of slavery. His outspoken condemnation of the slave trade was not just to be "politically correct." He spoke because he loved Africa, and he saw slavery as the destruction of

a people – a people he had come to love and respect.

Livingstone resigned from the London Missionary Society to focus entirely on his anti-slavery message. He had gained fame throughout England for his explorations and courage; now he was using that fame to stir the people's passions regarding the inhuman practice of slavery.

Following the death of John Hanning Speke, the Nile Duel raged on. Murchison needed a man – a seasoned explorer – and one whom the people trusted to tell the truth, who could settle the matter of the source of the Nile once and for all. He approached the famed explorer with the proposal.

Livingstone turned him down. He realized that his first obligation was to his family. If he went off to Africa again, it would leave his family without a sufficient income for their livelihood. Internally, he longed to return to Africa, but he also knew his scriptural obligation to his family.

Murchison assured him that his family would be well cared for in his absence. With that, he agreed to return to Africa.

Murchison's delight was expressed with the enthusiasm naturally accompanying the prospect of such a magnificent undertaking. "You" he told Livingstone, "will be the real discoverer of the source of the Nile."

From that moment on, finding the source of the Nile would be the compelling passion of Dr. David Livingstone. However, he had not completely accepted

the report of Speke regarding Lake Victoria being the source of the Nile. He had almost mystical beliefs that Herodotus had been right, and that the Nile did indeed begin with "fountains" springing forth from the foot of the "Mountains of the Moon." He felt deeply that there was a divine pattern in the geography of the river. These were the forces that drove him, and the solution to the Mystery of the Nile that he would seek. On August 14, 1865, he sailed for Africa.

In *The White Nile,* Alan Moorehead capsulizes Livingstone's adventure to find the source of the Nile in these succinct words:

> Never can there have been a journey which was founded upon so many misassumptions as this one. It was a search for the source of a river in a region where it did not exist; it was an anti-slavery expedition that had no power whatever to put down slavery; it was the march of a man who believed that he alone, unarmed and unsupported, could pass through Africa, and that was almost impossible. But none of this made any difference. Through a series of paradoxes all comes right in the end; the march goes on....Even the mystery of the Nile is solved – not by Livingstone himself but because he inspired another man to go off in another direction. And to Livingstone no doubt all this was as it should have been: it was the will of God.[1]

1 Alan Moorehead, The White Nile, Dell Publishing Co., Inc., New York, 1960, p.117.

4

The Will of God

Hindsight often reveals quite clearly the "will of God." Hindsight, however, does not show clearly the path ahead. Livingstone's search for the source of the Nile had taken on spiritual overtones. The river was a very special one – it was the life that flowed through a barren land. Finding it would be coming to the face of God.

But he looked in all the wrong directions. He still believed Herodotus' description of the four fountains springing forth from the foot of the Mountains of the Moon. And so he began his incredible wanderings, which were to continue for seven years. He had been well supplied with his every need by the Royal Geographical Society, but his own porters defected, taking with them his most valuable supplies. Still he pressed on. Often plagued by malaria and dysentery, and just plain starvation, his body grew weaker, even losing all his teeth, but his purpose was not thwarted – he would find the source at all costs.

Livingstone felt a deep personal relationship with God. In his journals he would write of his personal devotion to the God he loved so dearly. He sought His leading and His presence in all things. He prayed on his knees

and read his Bible daily. When his porters left him, taking all the valuable supplies, including the medicine box, Livingstone began a discussion with God which he recorded in his journals. "Everything of this kind happens by the permission of One who watches over us with most tender care, and this may turn out for the best. It is difficult to say 'Thy will be done,' but I shall try."

Without his supplies and his precious medicines, his promise to find the source of the Nile, and his unlimited faith in God gave him the strength and the determination to press on.

It was at a time when the "mystery of the Nile" was in full public view. Some had believed, as Montesquieu had written: "It is not given to us mortals to see the Nile feeble at its source." Livingstone believed it was *not* feeble at its source, but flowed from abundant fountains, just as life flows from God.

His search took him to Lake Tanganyika, where he had hoped to find a river flowing north. His ventures on the lake and its surrounding country brought him to the Lualaba River, which he believed to be the Nile. Its upper regions did seem to flow north, but then west. What he had found was the upper Congo River, that flows in a great north to west bending arc that eventually flows into the Atlantic. His exploration of the river came to an abrupt halt when he encountered an attack by the Arab traders on the innocent villagers at Nyangwe. The massacre was pointless and brutal – it was upon men, women and children. Livingstone wrote in his journal:

I was surprised to see the three with their guns, and felt inclined to reprove them, as one of my men did, for bringing weapons into the market, but I attributed it to their ignorance, and, it being very hot, I was walking away to go out of the market, when I saw one of the fellows haggling about a fowl, and seizing hold of it. Before I got thirty yards out, the discharge of two guns in the middle of the crowd told me that slaughter had begun; the crowds dashed off from the place, and threw down their wares in confusion, and ran. At the same time the three opened fire on the mass of people near the upper end of the market-place, volleys were discharged from a party down near the creek on the panic-stricken women, who dashed at the canoes.... The shooting party near the canoe were so reckless, they killed two of their own people.... My impulse was to pistol the murderers.... As I write, I hear the loud wails on the left bank over those who are slain, ignorant of their many friends who are now in the depths of the Lualaba. Oh let Thy kingdom come! No one will ever know the exact loss on this bright sultry summer morning. It gave me the impression of being in Hell.

Sickened and discouraged by what he had just witnessed, Livingstone struggled back to the village of Ujiji on Lake Tanganyika. His supplies were gone, his strength was fading, and there was little except his faith to keep him going. During his explorations of the Lualaba he had read the Bible four times.

As a result of the later publishing of his journals,

this account of the inhuman massacre of the innocent people of Nyangwe reached out to the world. It had raised a storm of indignation which forced the sultan of Zanzibar (Africa's slave port) to close the slave market on the island forever. But Livingstone did not live to see the abolishing of the slave trade which he so desperately abhored.

Porters who had desserted Livingstone, and taken his supplies and medicines, needed to justify their arrival on the coast with his supplies, so they reported that Livingstone had died. News of his alleged death reached England, and *The Times* published it for the world to see.

He was, in fact, barely alive when he reached Ujiji and was reduced to begging. In his utter despair, he wrote in his journal:

> I felt, in my destitution, as if I were the man who went down from Jerusalem to Jericho, and fell among thieves. But I could not hope for priest, Levite or good Samaritan to come by on either side.

Sir Roderick Murchison did not believe the rumors of Livingstone's death. He realized that he had not heard from the explorer in several years, but he was not willing to resign to failure in finding the source of the Nile. If Livingstone could be found, it would reach the newspapers of the world, and funds would begin coming in to support the expedition.

Because of the publicity, newspapers in other parts of the world climbed on the bandwagon. The story sold newspapers. And soon the search for the source was over-

shadowed by the search for Livingstone. The publisher of the New York *Herald* had an ingenious plan, never before plied in journalistic history. He would send his best journalist to Africa; he would find Livingstone, and thereby scoop the British.

It was October 27, 1869 when Henry Morton Stanley stepped inside the office of James Gordon Bennett, Jr., publisher of the New York *Herald*. He had been summoned for the unusual task of finding Dr. David Livingstone. When Bennett explained the awesome mission to which he was ordering Stanley to embark upon, the latter could only stand in dumbfounded disbelief. He was not an explorer. He was a journalist. How could he possibly find Livingstone in the unknown wilds of Africa? He immediately regarded the request as the extreme pursuit of stupidity.

However, Stanley knew Bennett's propensity for firing employees for things of much less magnitude, so he reluctantly agreed to undertake the mission. It was to be a top-secret journey. No word of it would reach the public until Livingstone had been found – dead or alive.

In February, 1871, Henry Morton Stanley arrived at the little port of Bagamoyo on the east coast of Africa. His every act was a cover-up for his real mission. False stories must be fabricated to explain the enormity of his 192-man caravan and his supplies (all of which had been funded by the New York *Herald*). His subterfuge took him to the south, rather than east into the heart of Africa.

Little did Stanley realize the enormity of his task

and the hardships he would have to endure in his quest to find Livingstone. He traveled more than seven hundred miles from Bagamoyo to Lake Tanganyika, through which many of his porters deserted, taking his supplies, his men and horses died of disease, and he, himself often becoming so ill that he had to be carried.

The final miles of his journey was experiencing a brutal tribal war, and it became necessary for him to blaze a new trail through the swamps and jungles in absolute silence, in the hopes of not being detected and killed, and his supplies looted. He had heard that a white man was said to be living in Ujiji, on the coast of Lake Tanganyika. He could only hope it was Livingstone. Information could only be obtained from here-say by the native people. All of Livingstone's messages had been confiscated by the Arabs for fear that his tales of slave brutality would reach the outside world and put an end to their lucrative trade. Thus Livingstone, his whereabouts and his safety, had been lost to the outside world.

Stanley's mission was to find him. And, although he was less than a hundred miles from Ujiji, he might as well have been a thousand, for his bout with cerebral malaria, followed by smallpox had left him extremely weak, and his caravan was running out of supplies. The starvation of his men made forward progress extremely slow.

On November 1, 1871 Stanley finally reached the Malagarasi River. The villages along its banks made it possible to restock their supplies, and feed his starving

porters. However, the way to Ujiji was on the other side of the river – a river whose crocodiles dotted the surface for as far as the eye could see. He hired local tribesmen to ferry his caravan across the river in canoes. But the donkeys were forced to swim. It was a perfect set-up for the hungry crocodiles, and Stanley's favorite donkey, Simba ("lion" in Swahili) was snatched and carried underwater, never to surface again.

The loss of Simba touched Stanley deeply, and he grieved openly for him. But by morning, a passing traveler told of seeing a white man in Ujiji. Stanley's spirits lifted immediately. Perhaps it was indeed Livingstone. He was filled with renewed hope and vigor, as the caravan set out that morning for Ujiji. They had still one more mountain to cross, but it was attempted in secret, not taking the usual trail, but hiding the caravan in an uncharted route, in silence.

From the summit of the mountain he looked down on the expanse of Lake Tanganyika which reached to the horizon beneath him, sparkling in the sunlight. He wrote in his journal: "In a few minutes we shall have reached the spot where we imagine the objects of our search. Our fate will soon be decided. No one in the town knows we are coming."

Stanley changed from his traveling rags into his best clothes and boots. A mile from Ujiji he ordered his men to raise the American flag at the head of the caravan. Then he gave orders for every man to load his guns. "Commense firing!" he shouted. Later he wrote in his journal: "The

flags are fluttering, the banner of America is in front waving joyfully. Never were the Stars and Stripes so beautiful in my mind."

At the sound of all the commotion, the townspeople came pouring out to meet the caravan. Soon, thousands of people pressed around them, and Stanley's eye searched the crowd for the face of a white man.

Meanwhile, Livingstone had been sitting in front of his small house, pondering his woeful future, when he heard the shouts and excited voices. Above the throng of people, he saw the American flag waving in the breeze. He had no idea that it was an expedition that had come to find "him." But he was elated to see a white man at the head of the caravan. He immediately hoped the man spoke English.

Stanley saw the white man in the sea of black faces and his heart pounded. He pushed through the crowd and stepped briskly to the old man with the white beard. He respectfully removed his helmet, and extended his right hand. Not knowing the proper "British" way of greeting the famed explorer, Stanley spoke in the most dignified words that came to his mind: "Dr. Livingstone, I presume?"

With a curious smile, Livingstone replied, "Yes."

Stanley was appalled at the fragile appearance of the old man, but his elation at having found him was bubbling up from within his own heart. "I thank God, Doctor, that I have been permitted to see you."

Livingstone replied, "I feel thankful that I am here

to welcome you." He did not yet know that this white man from America had come to rescue him. Nor did Stanley know that his paid mission to "find Livingstone dead or alive" was to be the turning point in his entire life.

The day was October 27, 1871, exactly two years, to the day, since Bennett had given Stanley the "Great Commission" to find Livingstone. It was also the very day of the burial of Sir Roderick Murchison in London.

On that day, Livingstone and Stanley sat on the veranda eating and drinking until well into the night. Stanley wrote in his journal: "I found myself gazing at him. Every hair of his head and beard, every wrinkle of his face, the wanness of his features, and the slightly wearied look he wore, were all imparting intelligence to me – the knowledge I craved so much."

Stanley's original plan was that upon finding Livingstone he would rush to Zanzibar and wire his story to the *Herald,* but now that he had found him, he set aside all ambition, and thrilled with the joy of basking in his newfound friendship. He fell in love with Livingstone.

During their five exhilarating months together, Stanley had found Livingstone to be the father-figure he had never known. The once lonely and rejected bastard child had now found a true father.

Stanley had been born John Rowlands – the product of the town drunk and a 19-year old whore. Early in life he had changed his name to Henry Morton Stanley. Now, in the wilds of Africa, after facing death and scores of

hardships, he found his true father, the man who had captured his heart and his devotion – Dr. David Livingstone.

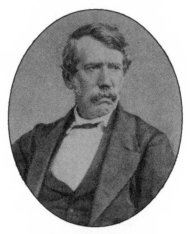

Dr. David Livingstone
(© Bettmann/CORBIS)

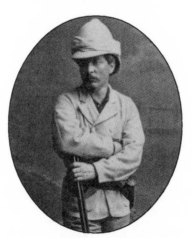

Henry Morton Stanley
(© Hulton-Deutsch Collection/CORBIS)

5

Dr. David Livingstone

"**D**r. Livingstone, I presume," first appeared in print in the July 15, 1872 edition of the *Herald*. It soon became world famous.

The saga of Livingstone and Stanley had captured the attention of the world. It began as a project of the Royal Geographical Society to find the true source of the Nile River. It developed into an epic adventure with portends far beyond its physical boundaries. It bears overtones of divine intervention, and the revealing of the work of God for the salvation of man through Jesus Christ.

The river and its source has been called "The Mystery of the Nile." More than any other river in the world, its source has been sought for centuries. Many have died in attempting to find the source from which flows the life-giving waters. Herodotus termed it correctly. He said "Egypt is the gift of the Nile." Truly, Egypt could not exist as a place of human habitation were it not for the life-giving flow of the Nile through the sands and rocks of its barren deserts.

The true source of the Nile, as Montesquieu suggested, is not "feeble." That source is rain falling from above on the vast surface of Lake Victoria. It is as if it

were a gift of God. And that, I believe, is precisely the intended illustration.

It is the second largest fresh water lake in the entire world – Lake Superior in North America being the largest. Lake Victoria covers an area of 27,000 square miles. In the number code of the Bible, the number 27 has beautiful significance.

27 = Pure, זך
27 = To illuminate, יגיד
270 = "A Star out of Jacob" (prophetic of Jesus)
כוכב מיעקב, (Numbers 24:17)

Water retention in the lake is 23 years. In other words, it requires 23 years for a complete renewal of the water. The number 23 in the Bible's number code represents both life and death. It was because of Jesus' death that we can have life.

23 = חיה, Living
 To give life
 To save life
23 = חטאה, Sin offering (Jesus entered into death as an offering for the sin of Adam.)

This volume of fresh water – pure because it comes from above – measures 729 trillion gallons. It is represented as coming down from God. In Genesis 1:1 we have the beginning – *In the beginning God,"* which has a

number value of 999. The number nine in the code of the Bible represents that which is perfect, complete, whole, full, and final. It is from this source that the pure water falls on Lake Victoria, filling it to 729 trillion gallons –
9 x 9 x 9 = 729.

The length of its coastline, 2140 miles, if it were a circle, would have a diameter of 681 miles. They are not random numbers, but define the purity of the life-giving waters that come from above as is represented in Jesus, the holy seed through which *"all the families of the earth"* will be blessed with fulness of life – the kind of life that Adam lost because of disobedience.

214 = pureness, טהר
681 = Perfect, $\alpha\rho\tau\iota\sigma\varsigma$
681 = A surety, $\varepsilon\gamma\gamma\upsilon\sigma\varsigma$
681 = The holy seed (Jesus), זרע קדש

The disobedience of Adam and his resultant fall from the perfection in which he had been created, is represented by the Great Rift into which the water from Lake Victoria plunges. It is a surety that victory had been purchased for Adam, even before he sinned. Lake Victoria beautifully represents *"the Lamb slain from the foundation of the world."* Victory was purchased for Adam, long before he needed it.

From the equator, at Lake Victoria, the water flows 4,000 miles until it reaches the mouth of the delta, and there stands the Great Pyramid, God's witness in the land

of Egypt, proclaiming to all ages and to all time that Jesus Christ has purchased life for Adam and all his progeny. And, indeed, 4,000 years from the very day that Adam sinned, Jesus hung on the cross of Calvary, paying the price and thereby redeeming Adam. But the world *"knew him not."*

In November of 1864, Sir Roderick Murchison, president of the Royal Geographical Society, presented to Dr. David Livingstone a proposal to travel to Africa to satisfy, for all time, the mystery of the source of the Nile. On August 14, 1865, Livingstone left British soil and sailed for darkest Africa. It would be a full 8 years before his body would return, to be buried in Westminster Abbey. Is there a similarity here to the experience of Jesus Christ, of whom it was prophesied, *"He made his grave with the wicked, and with the rich in his death."* (Isaiah 53:9)

Livingstone was a peaceful man. He had never been known to whip or even yell at his own men, but instead, preferred to settle all differences by gentle persuasion. Even in his dealings with hostile tribes who demanded tribute, his methods of dealing with them were through kindness, and after negotiating with kind persuasion, the hostile enemy would become a new ally.

Stanley was so impressed by the gentleness of his new-found friend, that he wrote in his journal:

> Dr. Livingstone is about sixty years old, though after he was restored to health he looked like a man who has not passed his fiftieth year. His hair

has a brownish color yet, but here and there is streaked with grey lines over the temples. His beard and mustache are very grey. His eyes, which are hazel, are remarkably bright. He has a sight as keen as a hawk's.... I grant that he is not an angel, but he approaches to that, being as near as the nature of a living man will allow.... His gentleness never forsakes him, his hopefulness never deserts him.

Livingstone was called a "Lion in repose." And, even though lions have lethal speed and accuracy over their prey, yet in repose they appear to be gentle, almost affectionate creatures.

His knowledge of lions, though, was up close and personal. He had once been attacked by a lion. He later wrote of the experience:

I saw the lion just in the act of springing upon me. He caught me by the shoulder as he sprang and we both came to the ground below together. Growling horribly close to my ear, he shook me as a terrier dog does to a rat.

It was the old lion wound that many years later would positively identified his body as indeed being none other than Dr. David Livingstone.

From the day that Stanley met Livingstone, his love for the famed explorer grew deeper as each moment passed. He attached himself to his new-found friend as a needy child would cling to a long-absent father. The bond between the two men was a deep mutual respect and affection. Livingstone became the father that Stanley had

never known. Together they circumnavigated Lake Tanganyika, searching for a river that flowed north. After nearly five months, it became necessary that the two men should part. Stanley must return to Zanzibar and from there to England; and Livingstone felt the overpowering need to continue his search for the source of the Nile.

But parting was painful. On the morning of March 14, 1872 they bid each other their final farewells. It was a tearful moment for both men as they stood arm in arm, savoring that last touch of affection. Livingstone asked Stanley to return, and to find the source of the Nile. Stanley promised the old man that he would return and fulfill that commission. And indeed he did.

Livingstone watched, through his tears, as Stanley walked toward the rising sun. He was alone once again, but with a renewed vigor and determination to continue his search for the source.

The next day Stanley, feeling deeply the separation from his dear friend, wrote a letter to Livingstone.

"My Dear Doctor,

I have parted from you too soon. I am entirely conscious of it from being so depressed.... In writing to you, I am not writing to an idea now, but to an embodiment of warm good fellowship, of everything that is noble and right, of sound common sense, of everything practical and right-minded.... Though I am not present with you bodily you must think of me daily, until the caravan arrives. Though you are not before me visibly, I shall think of you constantly, until your

least wish has been attended to. In this way the chain of remembrance will not be severed.

Stanley carried with him Livingstone's journals and a packet of sealed letters. Hopefully they would be proof to the outside world that the mission had been a success and that Dr. David Livingstone had been found. Unfortunately, even letters in Livingstone's own handwriting was not sufficient proof to many; they felt that Stanley was lying, even to the extreme of claiming that a clairvoyant had written it in the great explorer's handwriting to deceive the world.

In August of 1872, Livingstone embarked on his last journey of exploration. But what remaining health he enjoyed was ebbing away, and his bouts with chronic dysentery and bleeding hemorrhoids were sapping his strength. He knew that he could find refuge with the Arab slave traders, and with them, make his way to Zanzibar. But saving his life was not his choice. He had dedicated his life to revealing to the world the source of the Nile, and to this end he would continue, even if it meant his life. And it did.

In his journals he wrote, "Can I hope for ultimate success? So many obstacles have arisen. Let not Satan prevail over me Lord Jesus." His last written words were to be printed on his grave stone: "All I can add in my solitude is, May Heaven's rich blessing come down on every one, American, English or Turk, who will help to heal this open sore of the world."

The "open sore" was slavery, and his dying words

were for the healing of its wound upon mankind.

During the night of May 1, 1873, he awoke between midnight and dawn, and slipping to the floor, on his knees he breathed his last breath in prayer to God.

It was 4:00 a.m. when two of his men found him, still knelt in prayer. He was 60 years old.

The two men who found his body were his long-time friends and helpers, Susi and Chuma. They had been with him from the beginning of his journeys, and, although many others had deserted him, these two faithful companions remainded with him to the end. In their loyalty to their master, these two servants determined to carry his body back to England.

Getting his body from the heart of Africa to the port of Zanzibar was a near impossible task, but with deepest respect for their long-time master and dearly beloved friend, they set upon the task. First, they removed the heart of Livingstone and placed it in a tin box that he had once used to store his journals. At the base of a mpundu tree they buried the box, while reading prayers over the grave. The remainder of the body was salted and dried for two weeks in the hot sun. As it dried, the legs were bent back at the knees, making him shorter and easier to carry. Blue and white calico was wrapped tightly around him, then he was covered with a protective cylinder made from bark. Finally, the corpse was wrapped tightly in sailcloth, and hung between two poles. Two weeks after his death, Susi and Chuma began the long trek to Zanzibar where they would put him on a ship sailing for England.

The body of Dr. David Livingstone would be buried in England, but his heart would always remain in Africa.

With the body swaying like a banner from the poles, the caravan moved slowly, reaching the coastal town of Bagamoyo in February of 1874. After the short boat trip to the port of Zanzibar, the body was placed in a coffin awaiting a ship to take it to England. During the intervening days, a surgeon came to open the coffin and identify the body it contained. There was no doubt about the identity – the old lion wound on the shoulder was proof enough that it was indeed the body of Livingstone.

Eight years and eighteen days after his departure from England, Dr. David Livingstone finally returned. England went into mourning as the ship docked at Southampton to the thunder of a 21-gun salute. His flag-drapped coffin was transferred to a special train provided by Queen Victoria.

Upon arriving in London, the body was examined by Sir William Ferguson and five of Livingstone's friends. Although the drying process had completely obliterated his face, the sight of the shattered left shoulder – the old lion wound – was enough to convince them that this was indeed the old "Lion in repose."

England was in mourning. At half past noon on April 18, 1874, Livingstone's polished oak coffin was placed in a horse-drawn hearse, and the procession proceeded to Westminster Abbey. Twelve mourning carriages traveled behind the hearse. After these, the Queen's royal carriage, followed by the Prince of Wales. Thousands of people

lined the road in what would become Britain's largest display of mourning.

Of the magnificent event, the *Times* wrote:

> His body rests in peace, but his name liveth evermore.... Each of those present takes a long and parting glance at the great traveler's resting place, and at the oaken coffin buried in spring blossoms, and palms, and garlands wherein lies 'as much as could die' of the good, great-hearted, loving, fearless, and faithful David Livingstone."

Stanley was among the pallbearers. He stood long before the coffin of the man he loved so dearly. Although they had only spent five months together, his name would forever be linked with the great "Lion in repose."

He wrote in his journal: "When I had seen the coffin lowered into the grave, and had heard the first handful of earth thrown over it, I walked away sorrowing."

He had come a long way, from the bastard child of a prostitute, to a cabin boy on a sailing ship, to a roust-about in the wilds of Colorado, to journalist for the New York *Herald,* to the one who had shown the famed Dr. David Livingstone to the world. At long last he was successful, he was wealthy, he was famous. Yet he knew in that tearful moment, that he was willing to throw it all away to fulfill the promise he had made to his beloved friend, to finish the work he had begun, and to proclaim to the world the source of the Nile.

The world had a new "Lion" – his name was Henry Morton Stanley.

6

Henry Morton Stanley

As Stanley walked slowly away from Westminster Abbey that day, his mind was already planning the return to Africa. He must fulfill his promise to Livingstone and find the true source of the Nile. His need to publish it for all the world to see was a compelling force within his breast.

That same year, 1874, Stanley returned to Africa. Twelve years had elapsed since John Hanning Speke announced to the world that Lake Victoria was the true source. But the world had not believed him. Stanley's first mission upon reaching Africa was to prove or deny Speke's gigantic guess.

In the years since Speke's announcement, the systematic refutation of his claim led some geographers to draw new maps, replacing Lake Victoria by five small lakes. In their desire to negate Lake Victoria's importance, they obliterated it altogether from existence. Stanley planned to circumnavigate Lake Victoria and thereby establish whether or not it is one great lake, or five small ones; and he planned to investigate the stream pouring out at Ripon Falls to see if it was indeed the lake's only outlet.

He also planned to investigate the belief that Lake Tanganyika was the source of the Nile, by circumnavigating it and looking for a river that flowed north. And, finally, he planned to investigate Livingstone's unfinished work on the Lualaba. He would get a boat on the river, and follow it downstream to wherever it led, until he reached its mouth. He was not only going to settle the matter of the Nile, but of the whole pattern of lakes and rivers in Central Africa.

Funding for his exploits came from the New York *Herald,* and the London *Daily Telegraph.* He purchased 130 books about Central Africa, and set about finding men who could accompany and assist him on this awesome mission. Amazingly, he chose common men, from working-class families, who had no previous experience in such exploration.

Upon reaching Zanzibar, he amassed the remainder of his caravan. It included a 40-foot boat, the *Lady Alice,* which had been built in sections, and easily dismantled for portage. He carried eight tons of stores, and hired 356 men for porters and for other tasks. His caravan stretched a half mile along the trail. Of the 360 persons who began the 3 1/2 year journey to Lake Victoria, more than a hundred of these had been lost through desertion, sickness, and skirmishes with the local tribes.

They arrived at the south shore of Lake Victoria and viewed its awesome magnificence from the same spot where Speke had first seen it and had announced that "this is the source of the Nile." Speke, upon seeing its expanse

laid out before him, made the colossal guess that this was the source of the Nile. Stanley was not a guesser – he intended to get proof.

His men assembled the *Lady Alice*, and, leaving most of the men on shore, he set sail with eleven others on March 8, 1875 to explore the lake. They traveled along the east shore, and in three weeks' time they arrived at Ripon Falls, where the water from Lake Victoria plunges down into the Great Rift. Amazingly, he was greeted by a native dignitary wearing a red robe, who gave him gifts of bullocks and other presents. Stanley and his men were ushered into the king's presence.

On May 5, 1875, Stanley was back to his starting point. He had circumnavigated the entirety of Lake Victoria, and had settled the matter that it was indeed one great lake, and not five little ones. He also confirmed that its only outlet was on the north where it plunged over Ripon Falls, and that the only major stream that flowed into the lake was the Kagera on the west. Stanley wrote in his journal, which was later published for the world to see:

> Speke has now the full glory of having discovered the largest inland sea on the continent of Africa, also its principal affluent as well as its outlet. I must also give him credit for having understood the geography of the countries we travelled through better than any of those who so persistently opposed his hypothesis....

Stanley had confirmed the truth of Speke's discovery and had attempted to publish it to all the world.

It could still be argued, however, that the "feeble" ultimate source of the Nile was the little stream – the Kagera – which flowed from the 6,000-feet high mountains between Lake Tanganyika and Lake Victoria. In his epic book *The White Nile*, Alan Morehead summarizes the question thus:

> ...if the argument were carried to its logical conclusion it must be admitted that the river begins in the rains of the sky itself and that Homer was right when he spoke of the "Jove-descended Nile." For ordinary purposes it would seem most sensible to accept the site of the Ripon Falls as its source, since it is only from there that the mighty river confines itself to a definite course, at first northward through Lake Kyoga to Central Uganda, then westward over the Karuma and Murchison Falls to Lake Albert, then generally northwards again through the rapids of Equatoria, the swamps of the Sudd and the deserts of the south Sudan to its junction with the Blue Nile at Khartoum; then on again for thousands of miles through a vast waste of sand until it reaches the pyramids and green delta of Egypt.[1]

The epic explorations of John Hanning Speke, Dr. David Livingstone, and Henry Morton Stanley have given the world a magnificent awareness of the source of the Nile. Their collective lives have become a living parable.

1 Alan Morehead, *The White Nile,* Dell Publishing Co., Inc., New York, 1960, p.143.

7
A Living Parable

Jesus spoke often in parables. He told fictional stories that had meaning relating to God's plan for the salvation, redemption and restoration of man. He simply told the main events of the story, without much detail, because each parable was teaching a simple truth. Those who have studied these parables know that the whole lesson being taught can get lost and confused if we attempt to apply every little detail. It is the main events of the parable that teach the lesson intended.

This same general rule applies to the living parables in the Old Testament Scriptures. These stories were not fictional – they were about real people and real events – yet they served as examples of the outworking of God's plan for the ultimate salvation of man. The Apostle Paul explained this principle when he said:

> *Now all these things happened unto them for ensamples (types); and they are written for our admonition.* (I Corinthians 10:11)

While researching the marvelous events of the explorations of the Nile and the search for its source, it became more and more apparent that these events and

their principal characters also served as a living parable, whose interpretation became the actual events in the history of man's relationship to God. Over and over again, as I studied the lives of these explorers, I was overwhelmed by the similarities to the actual events of history regarding the coming of the Messiah and the work that He would accomplish in the earth, including the selection of His Bride.

These famous explorations and their discoveries happened in the era of the 1860s and 1870s. These were the decades of the great reformers and teachers whose works have brought Biblical understanding out of its "darkness" and into the awareness of the Christian world. It was a time when eagerness and thirst for "truth" was filling the hearts of men. The greatest Christian enlightenment regarding God's plan for the salvation of man through Jesus Christ paralleled these explorations to find the source of the Nile.

That source is rain falling on the surface of Lake Victoria, representing the life-giving blood of Christ that was given for man, even before Adam needed it. The flow of the river northward to its delta beautifully pictures the life-giving flow of that redemptive blood for the benefit of all mankind. It begins in darkest Africa. It begins in the midst of the cruel slavery to which those people were being subjected.

Adam had been created in perfection, but his disobedience to the law of God brought him out of that freedom down into the slavery to sin and eventual death. Thus

all who were of Adam's progeny inherited that slavery into which they were born. This is represented by darkest Africa. This is where the river begins, and this is where the explorers went, to find its source.

Although Dr. David Livingstone was not the first character in this living parable, he is, by far, the most prominent. While reading the story of his life and dedication to God, I could not help but fall in love with him. He was a man of simple kindness and gentleness of spirit. He never whipped his men, but settled their disobedience with gentle words, turning his enemies into friends. He taught them the Holy Scriptures. His communion with his Heavenly Father was a daily and hourly way of life. He deplored the slave trade and spent much of his life, while out of Africa, educating the public to an understanding of the cruelty and inhumanity of slavery.

On his stone in Westminster Abbey, the inscription reads "Brought by faithful hands over land and sea, here rests David Livingstone, Missionary, Traveller, Philanthropist, Born March 19, 1813, at Blantyre, Larkshire. Died May 1, 1873, at Chitambo's Village, Ulala. For 30 years his life was spent in an unwearied effort to evangelize the native races, to abolish the desolating slave trade of Central Africa, where his last words he wrote, 'All I can add to my solitude is, May Heaven's rich blessing come down on every one, American, English, or Turk, who will help to heal this open sore of the world.'"

This aspect of his life whispers the possibility that somehow Dr. David Livingstone may represent Jesus. This

possibility kept invading my awareness as I read further into his life and work. Then, having seen the beauty of the Gematria of the Hebrew Scriptures – a subject of my intense study for more than 40 years – I decided to find what the number value would be for the name "Dr. David Livingstone." As I punched it out on my calculator, I sat in stunned amazement. It bears the number 370 – a number that is replete in the Gematria of the names and titles of Jesus.

Doctor David Livingstone

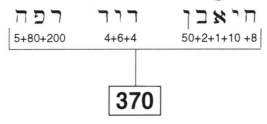

רפה דוד חיאבן

5+80+200 4+6+4 50+2+1+10 +8

370

370 = My Messiah, במשיחי, (Psalm 105:15)

370 = He rules, משל, (Psalm 66:7)

37 = Only begotten, יחידה

37 = Only son, היחיד

3 x 37 = Son of the Living God, בני אל חי, (Hosea 1:10)

4 x 37 = Christ (Messiah), Χριστος

7 x 37 = Only Son, Christ, υιος μονος Χριστος

8 x 37 = Son of man, υιος του ανθρωπου

9 x 37 = Lord of lords, Κυριος των κυριων

12 x 37 = The Lord Christ, τω Κυριω Χριστω

12 x 37 = Christ the Son of Man, $X\rho\iota\sigma\tau o\varsigma$ $\upsilon\iota o\varsigma$ $\tau o\upsilon$
 $\alpha\nu\theta\rho\omega\pi o\upsilon$
21 x 37 = The manchild, $\tau o\nu$ $\alpha\rho\sigma\epsilon\nu\alpha$
24 x 37 = Jesus, $I\eta\sigma o\upsilon\varsigma$
37 x 37 = The Son of David (Jesus), o $\upsilon\iota o\upsilon$ $\Delta\alpha\upsilon\iota\delta$
49 x 37 = Emmanuel, the Son of David, $E\mu\mu\alpha\nu o\upsilon\eta\lambda$ o
 $\upsilon\iota o\varsigma$ $\Delta\alpha\upsilon\iota\delta$

This is merely a small sampling of the long list of names and titles of Jesus that bear the number 37. The last one listed above is 49 x 37, which is 1813. I felt it to be significant that this one calls him the *"Son of David,"* bearing the number 1813, which, on the Gregorian calendar was the birth date of David Livingstone.

One day, while reading some experiences in the life of Livingstone to a friend, as I paused in my reading I heard him clearly say "Dr. David Living Stone." I stopped reading. Immediately the words of the Apostle Peter came flashing before my mind.

> *"To whom coming, as unto a living stone, disallowed indeed of men, but chosen of God and precious."* (I Peter 2:4)

Peter was suggesting that Jesus was the *"living stone."* How subtly, yet unmistakably, our God has woven together his plan for the redemption of man through Jesus Christ into the lives of those men who searched for the source of the Nile. The life of Dr. David Livingstone speaks loudly of the life of Jesus Christ. Let's look at some startling parallels.

A far country:

Livingstone left the comforts of home and family to give his life in the pursuit of making the world aware of the source of the Nile, as well as to abolish the slave trade in far-off Africa.

Jesus left the heavenly courts and the delights of his Father's presence to come to a "far country" – the earth – to make the world aware of the "water of life" that he was providing for all mankind. His ministry was to abolish the slavery to sin and death into which mankind had been trapped by the Adversary.

Why did Jesus do this? Part of the answer is given in Proverbs 8. He speaks of being with the Father from the beginning of creation (and indeed He was the beginning of creation); and he said, *"Then I was by him, as one brought up with him: and I was daily his delight, rejoicing always before him."* This was the joy he had in being with the Father. Yet, he goes on to add: *"Rejoicing in the habitable part of his earth; and my delights were with the sons of men."*

He had been with the Father and shared in the work of creating man – and he loved man. He had made them in the very image of the Father. Yet the man he made had become influenced by the great Adversary and had disobeyed divine law. It was in the plan from the beginning, that He would rescue man from slavery to sin and death. He rejoiced in the habitation of man – the earth – and knew that He was the One who had been granted the privilege of providing the water of life.

When the fulness of time was come, God sent forth his Son. (Galatians 4:4)

It was the Son's delight to provide the water of life for his human family whom he loved so dearly.

Rejection:

David Livingstone was never able to show to his countrymen the true source of the Nile, "Egypt's heaven descending spring."

Jesus came to show to his countrymen the true source of the water of life, but they rejected him.

He was in the world, and the world was made by him, and the world knew him not. He came unto his own, and his own received him not. (John 1:10-11)

But ye denied the Holy One and the Just ... and killed the Prince of life..." (Acts 3:14-15)

The Lion:

Livingstone was called the "Lion in repose." His personal encounter with a lion left him with a permanent scar. For the remainder of his life he bore in his body the identification of the lion. After his death this mark of the lion served to positively identify him as indeed being Dr. David Livingstone.

Jesus is called the *"Lion of the tribe of Judah."* (Revelation 5:5)

Character:

The epithet "Lion in repose" was given to Livingstone because of his gentle nature. A sleeping lion appears to be cuddly and lovable. Martin Dugard, in his excellent book *Into Africa,* described Livingstone's gentle, yet powerful character:

> Livingstone never whipped or harangued his men, preferring to settle all differences through gentle persuasion. Even more surprising was how Livingstone used the same method with hostile tribes demanding tribute.... by the time Livingstone had negotiated their way out of one problem or another, a hostile tribe or recalcitrant porter was often a new ally. [1]

The Apostle Paul spoke of the *"meekness and gentleness of Christ"* in II Corinthians 10:1.

Finish the work:

On New Year's Day, 1871, Livingstone wrote in his journal: "Oh Father, help me to finish this work to thy honor." His desire to present to the world the source of the Nile was an all-consuming passion. He felt it was the work that God had given him to do, and he would stop at nothing short of its accomplishment, regardless of illness or personal hardship.

Shortly before his death, he wrote in his journal: "I am pale, bloodless, and weak from bleeding profusely. An artery gives off a copious stream, and takes away my

1 Martin Dugard, *Into Africa,* Broadway Books, New York, 2003, p. 276.

strength. Oh how I long to be permitted by the Over Power to finish my work."

Jesus, from the age of 12, knew that it was His mission to do the work of His Father, and he never ceased until on the cross when He said, *"It is finished."*

John 17 records the prayer that Jesus offered up to His Father on the night before His death.

> *Father, the hour is come ... I have glorified thee on the earth: I have finished the work which thou gavest me to do...* (John 17:1-4)

On his knees:

On the night of May 1, 1873 Livingstone, now very ill and bleeding, and knowing that his death was imminent, slipped out of his bed and onto the floor on his knees. There, with his head bowed over his bed, he prayed to his Father in heaven. The words of the prayer were not recorded. However, on previous occasion, when considering his impending death, he had written "Not my will, but Thine be done." He died on his knees.

Jesus, in the Garden of Gethsemane, slipped to his knees and communed with His Father in much the same prayer. He said,

> *"Oh Father, if it be possible, let this cup pass from me: nevertheless not as I will, but as thou wilt."*

The death process began in his perfect body at the point where he surrendered His will to the Father. It was there that blood clots began to drop from his brow to the

ground. The Roman soldiers took him, and scourged him with a cat-of-nine-tails, tearing the flesh from his back. From there his weakened and bleeding body was forced to walk to the hill of Calvary, where they drove nails through his hands and his feet. His bleeding body was lifted up on a cross to die. But death had begun while on his knees in Gethsemane.

Burial:

Livingstone's heart was removed from his body and buried in Central Africa. His body was lifted up on a pole and carried across Africa to be sent by ship to England. He was given a royal funeral and buried in Westminster Abbey – the place where kings were interred.

Isaiah prophesied of Jesus:

He made his grave with the wicked, and with the rich in his death. (Isaiah 53:9)

And just as Moses had raised up the copper serpent on a pole, Jesus said:

And as Moses lifted up the serpent in the wilderness, even so must the Son of man be lifted up: that whosoever believeth in him should not perish, but have eternal life. For God so loved the world that he gave his only begotten Son, that whosoever believeth in him should not perish, but have everlasting life. For God sent not his Son into the world to condemn the world; but that the world through him might be saved. (John 3:14-17)

And just as Livingstone had been interred in a rich man's grave, it was prophesied of Jesus that he would be placed into a rich man's tomb. And so, we have the fulfillment of Isaiah's prophecy:

...there came a rich man of Arimathaea, named Joseph, who also himself was Jesus' disciple: he went to Pilate, and begged the body of Jesus. Then Pilate commanded the body to be delivered. And when Joseph had taken the body, he wrapped it in a clean linen cloth, and laid it in his own new tomb, which he had hewn out of the rock: and he rolled a great stone to the door of the sepulchre, and departed. (Matthew 27:57-60)

But Isaiah also said that *"he made his grave with the wicked."* May I suggest that the heart of Livingstone, being buried in darkest Africa, the place of slavery, was, in a sense, the heart of Jesus, which was given for sinful man – man that had fallen into the lowest depths of slavery to sin and death.

Livingstone was interred in Westminster Abbey on April 18, 1874. The sum of the digits becomes 33. $(4 + 1 + 8 + 1 + 8 + 7 + 4 = 33)$ Jesus was 33 years old at the time he was laid in the rich man's grave. If we multiply the digits we get $4 \times 1 \times 8 \times 1 \times 8 \times 7 \times 4 = 7168$. What a magnificent confirmation that Livingstone's death and burial represented the death of Jesus and his being buried in Joseph's tomb! Jesus died 4,000 years from the time when Adam sinned. He was the "second Adam," but in

the New Testament he is called *"Lord Jesus Christ."* The Gematria of His name is magnificent!

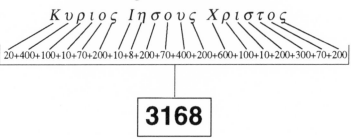

Lord Jesus Christ

$Kυριος$ $Iησους$ $Xριστος$

20+400+100+10+70+200+10+8+200+70+400+200+600+100+10+200+300+70+200

3168

 3168 = Lord Jesus Christ
+ 4000 years from Adam's sin to Jesus' death
 7168

7168 = 4x1x8x1x8x7x4 (date of Livingstone's
 burial in Westminster
 Abbey)

 The descent of the Nile from its source in Lake Victoria to its Delta is 4,000 feet. During that descent, it travels a distance of 4,000 miles. The date of Livingstone's burial in a rich man's grave obviously tells us of the death of Jesus, after 4,000 years of mankind's slavery to sin and death.

 The date of Jesus' death and burial tells us of the "hope" He has given us of "deliverance" from the

slavery to sin and death. Doing the exact same calculations as above, but using the date of His death on Calvary and his burial in Joseph's tomb, we obtain the magnificent numbers shown below.

April 3, 33 – the date of Jesus' death and burial
4+3+3+3 = **13**
4x3x3x3 = **108**

130 = Deliverance, הצלה
130 = Hope, ελπιδα
1300 = We will be glad and rejoice in His salvation, נגילד ונשמחה בישועתו, (Isaiah 25:9)

108 = He was pierced, מחלל, (Isaiah 53:5)
108 = Red (his blood), חכלילי

In the Gematria of the Bible, the numbers 1 and 8 always have reference to the Beginning and the New Beginning, and thus to the Beginner and the New Beginner. Jesus is the New Beginner, and His name in Greek has a Gematria value of 888.

Jesus said *"I am the Alpha and the Omega."* He was, of course, referring to the beginning and the beginning again of the Greek alphabet. The letter *"Alpha"* has a Gematria value of 1, and the letter *"Omega"* is 800.

In the first chapter of the book of Revelation, Jesus identified himself to John by saying, *"I am the Living One."* It has a number value of 1800.

Another actor makes his appearance on the stage of this real-life drama. The world knows him as Henry Morton Stanley; but his birth name was John Rowlands.

Born of a 19-year old whore and the town drunk; abandoned to a work house at the age of 5; escaped and found a job as a cabin boy on a sailing vessel; bummed his way to the American west; bluffed his way into a job as journalist for the New York *Herald,* and eventually assigned the task of walking into the unknown regions of darkest Africa to find the missing Dr. David Livingstone – this was the biography of Henry Morton Stanley. Not a likely candidate for success and fame.

Yet he successfully finds Livingstone; falls in love with him; confirms the true source of the Nile as being Lake Victoria; and publishes it for all the world through the *Herald.* Upon his death he was given an honorable funeral in Westminster Abbey, but buried in an unknown grave some miles away.

In this living parable, it has appeared that Dr. David Livingstone plays the role of Jesus Christ at His first advent.

> *He was in the world ... and the world knew him not. He came unto his own, and his own received him not. But as many as received him, to them gave he power to become the sons of God, even to them that believe on his name.* (John 1:10-12)

Henry Morton Stanley plays the role of those "believers." But their background is a bit unsavory. The

natural father of believers is fallen Adam, and they became bastard children of Mother Earth. But John said that because they *"received him"* they were begotten again as *"sons of God."* This was by a holy anointing which took place on the day of Pentecost in A.D. 33.

Stanley was born John Rowlands. The meaning of the name John is *"grace of God."* Believers are indeed children of grace. It is by the *"grace of God"* that these bastard children can become *"sons of God."*

God chose these children of grace, to be a Bride for his Son. These believers, upon recognizing their beloved Jesus, fall in love with him, just as Stanley fell in love with Livingstone.

Just as Livingstone was not able to show the world the true source of the Nile, so Jesus, at His first advent was not accepted by *"His own"* people as being the true source of life – their Messiah. However, the true believers, the prospective Bride, do indeed see Jesus as the river of life. It has been the mission of the prospective Bride to proclaim to all the world the *gospel* (good news) of life through Jesus Christ.

Stanley proclaimed his finding of Livingstone and his confirmation of the true source of the Nile through the *Herald.* The word "herald" means to proclaim. In the Hebrew Old Testament Scriptures the word translated *"herald"* is קָרָא, pronounced *kaw-raw*. It has a Gematria value of 301. This is one of the most beautiful numbers in the entire Bible, for it has reference to the water of life that has been provided for us through the

sacrificial death of Jesus Christ – and the proclaiming of it to all the world.

Let's pause for a moment, in the drama, and look more closely at the meaning of the number 301 and its relation to the *Herald* – Stanley's means of telling to all the world his finding of Livingstone and the true source of the Nile.

301 = From the River, רהנמר, (Zechariah 9:10)

This text reads, *"His dominion shall be from sea to sea and from the River to the ends of the earth."* Obviously the "River" in this text refers to the Nile. The symbolism is that the "River of Life," as is represented by the Nile, is in fact the life-giving blood of Jesus Christ, flowing from its source at the equator in Lake Victoria – flowing to the *"ends of the earth,"* or to all mankind who have ever and will ever live on this earth. This text is a prophecy that gives us the promise and the surety of His world-wide Kingdom of peace – a Kingdom that is soon to be established in the earth.

301 = Calvary, κρανιον

It was on the hill called Calvary that Jesus was lifted up on the cross and died a sacrificial death for the sin of Adam, providing the means of life for all of Adam's race. This hill was often simply called *"The Rock"* because it was known that this same rocky hilltop had once been the

place where Abraham had offered his son Isaac, as God had directed him to do.

301 = The rock, הצור
301 = Ornan, (Araunah), ארנן

The man Ornan, or as he was also called, Araunah, owned this rocky hilltop in the days of King David. But David chose it as a place where he desired to make sacrifice to God, so he purchased it from Araunah. It later became the hill where Solomon built the beautiful Temple. In fact, because of its use down through history, it has become known as the meeting place between God and man.

301 = Great drops of blood, θρομβοι, (Luke 22:44)

This text describes Jesus in the Garden of Gethsemane, kneeling before his Father in heaven. He had given his own will over to the Father when he said *"Not my will but thine be done."* At the surrendering of his will the death process began. *"Great drops of blood"* is a translation from the Greek word *thromboi,* which means "large drops of thick clotted blood." Some feel that this text is spurious and has been added by a later hand, but the evidence is that it is indeed authentic, and it describes the point at which Jesus began to die. This would have been after sundown on Thursday. His crucifixion was the next afternoon.

301 = Moon, σελην η

301 = Lambs, אמריך

It was on this rocky hilltop that Jesus hung on the cross and completed the death process at 3:01 in the afternoon. The moon was full. Just as it reached its maximum fullness, it began to eclipse. The time was 3:01 U.T. He was the antitypical Lamb – but at 3:01 in Jerusalem that day, the priests were slaying the typical Passover lambs.

301 = To bear the sin of another, to lift up, or to
 pardon.Used in Genesis 13:14 and 50:17. שא

301 = Pardon, ררצה

Jesus was lifted up on the cross in order that he might "lift up" all mankind from the slavery to sin and death. He bore the sin of another. He did not die for any sin that he had committed, but rather for the sin of Adam.

301 = From the rising of the sun, וממזרח

This use of the number 301 is from Isaiah 59:19. The text reads, *"So shall they fear the name of the Lord from the west, and his glory from the rising of the sun."* This is the ultimate result of the establishing of the Kingdom of God in the earth. *"As far as the east is from the west, so far hath he removed our transgressions from us."* (Psalm 103:12) The life-giving blood of Jesus, represented

by the Nile river, will have a world-wide effect, bringing the human race back into all that their father Adam had lost because of sin.

Stanley's love for Livingstone was expressed in his journal, after only one day of being together. It sounds as if he were writing a description of Jesus.

> I grant that he is not an angel, but he approaches to that being as near as the nature of a living man will allow.... His gentleness never forsakes him, his hopefulness never deserts him. No harassing anxieties, distraction of mind, long separation from home and kindred can make him complain. He thinks all will come out right at last.

This is as the prospective Bride sees her Lord. It reminds us of the words of Solomon when describing the Bride's love for her Beloved:

> *He is altogether lovely. This is my Beloved, and this is my Friend.''* (Song of Solomon 5:16)

It was a sad day for Stanley when Livingstone parted from him. Stanley would never see him alive again. After having basked in the presence of his beloved friend, Stanley felt alone and saddened. It reminds us of the day in A.D. 33 when Jesus and his disciples walked to the Mount of Olives. It was from there that they watched Him disappear into a cloud above. They stood there stunned with grief, for they loved Him. But only ten days later they were given the commission from on high to go and tell the world the good news – that Jesus had purchased

life for all mankind, and that He would return to set up his Kingdom among them.

Thus Stanley, upon seeing his beloved friend disappear into the wilds of Africa, hurried to tell the good news to the world. Martin Dugard, in his magnificent work *Into Africa,* expressed it thus:

> The focus of Stanley's mission changed as he turned away from Livingstone. No longer was he racing into the unknown. Africa was not an obstacle in that sense anymore. Now it was an impediment to sharing the news about Livingstone. The travails between him and Zanzibar – the Ugogo, the Makata Swamp, fevers, thorns, and the rainy season – were no less than before. If anything the journey would be more daunting, for Stanley planned to travel at breakneck speed.
>
> He carried Livingstone's journals and a packet of sealed letters from the explorer. They were Livingstone's communiques to the outside world, and the key to unlocking the mysteries about his whereabouts those many years. To Stanley, however, they were something just as vital and important: Proof.[1]

And so the prospective Bride has carried the good news to the world, bearing the very words of Jesus as proof that He was the Messiah, and that he had provided the "river of life" for all mankind.

Therefore they that were scattered abroad went everywhere preaching the word. (Acts 8:4)

1 Martin Dugard, *Into Africa,* Broadway Books, New York, 2003, p.284.

After the burial of Livingstone in a "rich man's" tomb, Stanley returned to Africa, in 1874, to find and confirm the source of the Nile. Upon reaching Lake Victoria at the same spot where John Hanning Speke had first seen the magnificent lake, he had his men assemble the *Lady Alice* – the boat they had brought in pieces. He specially chose 11 others to accompany him on his circumnavigation of the lake, and to investigate Ripon Falls, which Speke had proclaimed to be the beginning of the Nile.

It was with much anticipation that I found the Greek spelling of *Lady Alice,* and added its number equivalents. Somehow I had the feeling that it would be an important number in the Gematria of the Bible. However, I did not anticipate the impact the sum of its numbers would have on me.

Lady Alice

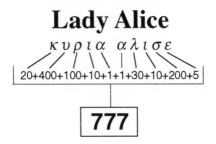

κυρια αλισε

20+400+100+10+1+1+30+10+200+5

777

There were 12 who set sail on the *Lady Alice*. It speaks loudly of the 12 Apostles who were sent forth to preach the good news to all the world, that Jesus was indeed the Messiah, that he had died and rose again, and had ascended to the Father. Those Apostles were the foun-

dation of the future Bride. They went proclaiming the love of God that had been displayed in the offering of Jesus for the sin of Adam.

Love of God

Stanley and the 11 men set sail in the *Lady Alice* on March 8, 1875, and 37 days later arrived at Ripon Falls. Upon arrival at the falls which Speke had claimed to be the beginning of the Nile as it flowed from Lake Victoria, Stanley was surprised to see a dignitary from the tribal kingdom, dressed in red, coming to meet him.

Alan Moorehead, in *The White Nile*, described the greeting in these words:

> Presently a dignitary in a red robe came forward to meet them with gifts of bullocks and other presents; and on April 5, 1875, Stanley was conducted into Mutesa's presence.[1]

Mutesa was the king of a vast empire of three million people which stretched for about 150 miles along the north and western shores of Lake Victoria. The overtones

1 Alan Moorehead, The White Nile, Dell Publishing Co., Inc., New York, 1960, p. 136.

of this event speak of the gift of life through the antitypical "bullock" – Jesus Christ – and ultimately being ushered into the presence of the King.

The story of Henry Morton Stanley, however, does not end victoriously, but contains elements of unfaithfulness to the cause of abolishing slavery in Africa. Stanley compromised his principles and accepted money from King Leopold II of Belgium to help create the Congo Free State, and promote the slave trade. It was because of this act of compromise that he was denied burial in Westminster Abbey.

At first this unfaithfulness and compromise of convictions puzzled me, for it did not sound like anything that would illustrate the faithful Bride. Then I looked at reality. The history of the church during the two thousand years since its small beginnings on the day of Pentecost in A.D. 33 has suffered many displays of unfaithfulness; so much so that it became necessary for the remnant of faithful believers to separate herself from the powerful organizations of Christendom. Those organizations had compromised their original faithfulness and had allied themselves with civil powers, and to a large extent fallen back into the ways of the world.

The history of the church can be seen as a large group of unfaithful participants, not having separated themselves from slavery to sin and death; and a small scattering of faithful individuals who remain faithful to their commitment. Thus in Revelation 18 we have the call to these faithful individuals to *"come out"* of those unfaithful

systems. I suggest that the experiences of Henry Morton Stanley represent both groups. He was given a royal funeral in Westminster Abbey, but was denied interment there. His body was cremated and buried twenty-five miles away in a small village churchyard.

Henry Morton Stanley was born John Rowlands. His name change reminds us that the faithful Bride experiences a name change also.

> *To him that overcometh will I give to eat of the hidden manna, and will give him a white stone, and in the stone a new name written, which no man knoweth saving he that receiveth it.* (Revelation 2:17)

It was Stanley who confirmed and proclaimed to the world that Lake Victoria was the source of the Nile and that the river began at Ripon Falls where the water plunges down into the Great Rift. The discovery of this "key" to the source of the river, was however, many years earlier by John Hanning Speke. But the Royal Geographical Society had not believed him.

Speke had not truly investigated the lake, but only stood on its southern shore and viewed this vast body of water. He wrote in his journal:

> I no longer felt any doubt that the lake at my feet gave birth to that interesting river, the source of which has been the subject of so much speculation and the object of so many explorers.

Alan Moorehead, in *The White Nile*, expresses his response to this kind of guesswork:

It was a reckless and astonishing conclusion to jump to, and it was quite impossible for Speke to back it up with any scientific proof.[1]

In this living parable, it appears that John Hanning Speke represents Israel's ancient prophets, all of whom spoke of the coming of the Messiah and of His work of the restoration of man in the Kingdom that He would establish in the earth. And, perhaps, the Royal Geographical Society, and its president Sir Roderick Impey Murchison may represent the nation of Israel under the spiritual rulership of the Pharisees at the time of the first advent of Jesus.

I am not suggesting that the prophets of old were "guessing" when they foretold the coming of Messiah. They were quite obviously writing under the inspiration of a power much more knowledgeable than themselves. But from the testimony of the scriptures, they often did not understand what they wrote, and from their stance, their prophecies were unproven.

Concerning this salvation, the prophets, who spoke of the grace that was to come to you, searched intently and with the greatest care, trying to find out the time and circumstances to which the Spirit of Christ in them was pointing when he predicted the sufferings of Christ and the glories that would follow. It was revealed to them that they were not serving themselves but you ... (I Peter 1:10-12, NIV)

1 Alan Moorehead, *The White Nile*, Dell Publishing Co., Inc., New York, 1960, p.45

Yet, those ancient prophets all spoke of the coming of the Messiah, either directly or in symbolic language. The fact of the Life-giver was the message they wrote, but it was probably not understood that He would come as the man Christ Jesus, to pay the price for the sin of Adam. On his first expedition, we are told, Speke never actually saw where the flow of the water from Lake Victoria spills over the escarpment and down into the Rift. He did, however, draw some maps, using information that had been told by the locals. In those maps he shows Ripon Falls.

Upon his return to England his report of his discoveries led to a second expedition. This time Speke approached the river from about 40 miles north of the lake. Upon reaching the magnificent river he was overwhelmed with its beauty. In his own words we have the glory and the majesty that he beheld. He wrote in his journal:

> Here at last I stood on the brink of the Nile; most beautiful was the scene, nothing could surpass it! It was the very perfection of the kind of effect aimed at in a highly developed park: with a magnificent stream, 600 to 700 yards wide, dotted with islets and rocks.

Speke was spellbound with the beauty of the river. He told his men they "ought to shave their heads and bathe in the holy river, the cradle of Moses." Perhaps this portrays the work of Israel's last prophet, John the Baptist. He was the one to make the announcement to Israel that

their Messiah had indeed come, and was in their midst. But their response was to behead him.

Speke did actually reach Ripon Falls – just as John the Baptist was permitted to actually see and behold his Messiah. John sought for proof, and received it. Speke also sought for proof, and when he beheld the falls he wrote:

> It was a sight that attracted one for hours ... the roar of the waters, the thousands of passenger-fish leaping at the falls with all their might; the ... fishermen coming out in boats and taking posts on all the rocks with rod and hook, hippopotami and crocodiles lying sleepily on the water...

It was on July 28, 1862 when they actually saw these magnificent falls. The escarpment blocked their view of the lake, but from the base of the falls they could see the great stream pouring itself out from the abundance above like a breaking tidal wave. And, indeed, when John the Baptist saw Jesus coming to him at the Jordan to be baptized, the impact was like a breaking tidal wave upon a society who longed for deliverance. John said,

> *Behold the Lamb of God which taketh away the sin of the world.* (John 1:29)

John made the announcement for which he lost his life. For the ruling class of his day were not willing to accept the Messiah or the one who had come proclaiming the Messiah.

Speke and his dwindling party did not attempt a return trip across the jungles and swamps of central

Africa, but rather traveled down the Nile to Cairo at the mouth of the river where it fans out into its mighty delta. The survivors numbered 18 men and 4 women. Upon reaching Cairo they were given three years' pay and a passage to Zanzibar, where a further bonus was awaiting them.

Upon Speke's arrival in England, the Royal Geographical Society was not as cordial as before, and refused to believe his tales of finding the source of the Nile. They preferred to believe the former explorer, Sir Richard Francis Burton, who insisted that the Nile comes from several lakes in central Africa not including Victoria. And during the 2,000 years since the announcement by John the Baptist that Jesus is the *"Lamb of God that taketh away the sin of the world"* many doctrines of "salvation" have been taught to supplant the true nature of the "Ransom for All" that was provided by the death of Jesus.

September 16, 1864 was the day planned for the famous "Nile Duel" in which Burton and Speke were to address the Royal Geographical Society with their theories and "evidence." But the duel never happened. Shortly before the hour it was to begin, Speke accidentally shot himself with his own gun. He was climbing a wall when the gun, wedged against a rock, accidentally discharged. The evidence for the source of the Nile was never brought to debate. Sir Roderick Murchison and the Royal Geographical Society refused to believe Speke's discovery.

Speke was buried in a small churchyard near his family home. Later a granite obelisk was erected in

Kensington Gardens in London. Its inscription reads, "In memory of Speke, Victoria Nyanza and the Nile, 1864." Thus also Israel's last prophet – the one who personally knew Jesus Christ – who had announced that He was indeed the One to take away the sin of the world, was beheaded.

Shortly after Speke's death, Henry Morton Stanley was given the assignment to find Dr. David Livingstone.

His greeting upon finding the famous explorer became a household phrase: "Dr. Livingstone, I presume" is the response of the prospective Bride when she first finds her Lord. The instant response of the prospective Bride is love for the One she has found, and a desire to learn from Him all that He desires to teach.

That day, and the very hour, in which Stanley met Livingstone, was the same hour in which Sr. Roderick Impey Murchison was being lowered into his grave. I suggest it is not by blind coincidence that the two events happened on the same day and at the same hour – November 10, 1871.

If, in this living parable, Murchison represents Israel and its religious leaders under the Law, they had looked for the Messiah but rejected him when he appeared. The very day that Jesus died on the cross, he put an end to the old Law Covenant and opened a *"new and living way"* by a New Covenant.

The writer of the book of Hebrews explained this transaction, and the transfer from the old Law Covenant to which Jesus had put an end by His death, to a new Law

Covenant which would indeed bring life.

> *For if the first covenant had been faultless* (not that there was anything wrong with the Law, but the fault lay in the inability of the people to keep it), *then should no place have been sought for the second. For finding fault with them, he saith, Behold, the days come, saith the Lord, when I will make a new covenant...* (Hebrews 8:7-8)

> *Then said he, Lo, I come to do thy will, O God. He taketh away the first, that he may establish the second, by which we are sanctified through the offering of the body of Jesus Christ once for all.* (Hebrews 10:9-10)

Both events happened on the same day. Murchison, who represents the recipients of the old Law Covenant, was lowered into his grave on the same day, and at the same hour, as Stanley found Livingstone.

There is probably much more to this living parable than the mere outline that has been suggested here. And time may bring many more evidences to light. However, the evidences that have become obvious appear to go beyond the possibility of "chance history" and into the category of planned events. That these events are vitally connected with the Nile River gives further suggestion that the river itself is an allegory of time and events in the plan of God for the salvation of man.

With this possibility before us, let's take a closer look at The River.

8

The River

This world's longest river, flowing north through the barren deserts of Africa becomes a river of time, flowing through the ages of man, to the destination of the Mediterranean. The scriptures give us the illustration that God dwells in the "north." This river flows toward God. It is illustrating the redemptive work of Jesus Christ in providing life for all mankind, and bringing them back to God, from whom they had become estranged by the sin of Adam.

With this magnificent picture before us, let us take a closer look at The River.

Livingstone believed there was a "divine pattern" in the geography of the river. That pattern begins to unfold as we trace the river from its source to its delta. As this magnificent river of life – this river of time – wends its way northward to the great sea, the Mediterranean, it defines the Bible's story of the fall, redemption, and restoration of man. As it cuts its way through the arid deserts of Egypt it brings life and refreshment to all who are watered by its abundance. It is, in fact, the only source of life through the barren sands of Egypt.

This Promise, written in sand, begins as rain falling

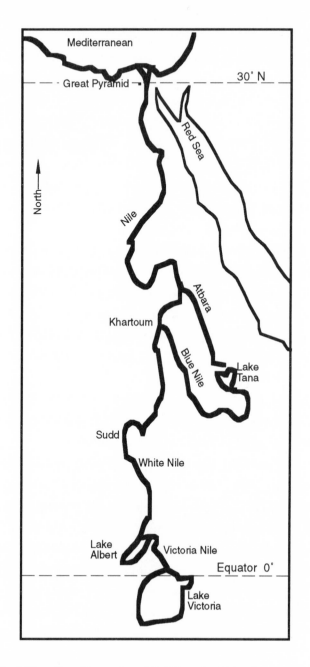

Mediterranean

Great Pyramid —

30° N

Red Sea

North

Nile

Atbara

Khartoum

Blue Nile

Lake
Tana

Sudd

White Nile

Lake
Albert

Victoria Nile

Equator 0°

Lake
Victoria

80 Nile: the Promise Written in Sand

from above. Egypt's very life indeed comes down from the great Source of life – our Creator. Egypt is used in the Bible as a type, or illustration, of the world of man, in the barren desert of sin. Egypt is indeed the "gift of the Nile."

The story of the river begins at the Equator, which of course is 0° latitude. The vast unlimitedness of the sun sheds its light and its warmth on the vastness of Lake Victoria. It is a seeming "transfer" of light and warmth from the sun to the lake. The symbology involved is beautiful.

From earth, the brightest thing we see in the sky is the sun. Men once worshipped the sun, concluding that it must be God because all life appeared to come from its rays. Their analogy was not quite accurate, but the sun is indeed a *symbol* of God. It is from Him that all life proceeds and is nourished. The mean distance that light comes from the sun to our earth, at the equator, is 93 million miles. This is, of course, a rounded figure, but the one generally used to denote this distance. It appears to be an intended figure – intended by the Creator.

In calculating this distance, it must be remembered that earth's orbit is an elliptical one; and earth's shape is not precisely spherical, but bulges at the equator. But in earth's relationship to the sun, something truly magnificent is revealed. The actual distance that the earth travels in its elliptical orbit of the sun is 595 million miles. Convert this figure to feet and we obtain 31,416 (dropping all the zeros). Does something look familiar about that figure? Simply remove the comma and insert a decimal

point, and we have the familiar number for *pi* – 3.1416.

What a marvelous design! It gives us an awareness of the awesome mind of the Designer, who used an ellipse to show the value of *pi*, when *pi* is actually the key to the geometry of a circle. Perhaps it is telling us that even though the orbital path of the earth around the sun is an ellipse, mathematically and symbolically it can be treated as a circle.

Let's try treating it as a circle and observe a fantastic design – a design that brings us to Lake Victoria and the beginning of the Nile.

If the earth were perfectly spherical, and if its orbit were a perfect circle, the distance that light travels from the sun to our earth would be 93 million miles. Convert that distance to inches and we would have 5,892,480 (dropping all the rest of the zeros). Divide this figure by the speed of light (again dropping the zeros), and the result will be 3,168, which, as we have seen, is the Gematria value of the name Lord Jesus Christ as is spelled in our Greek New Testament.

Lord Jesus Christ

Κυριος Ιησους Χριστος

20+400+100+10+70+200+10+8+200+70+400+200+600+100+10+200+300+70+200

3168

This is not a random coincidence. Let's try it again, but this time we'll divide by the circumference of the earth (if the earth were a perfect sphere), and surprisingly we get the Gematria value for the name Jesus Christ. The figures look like this: 5,892,480 ÷ 24,881.392 = 2368.

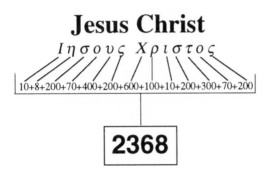

Jesus Christ

$I \eta \sigma o \upsilon \varsigma \; X \rho \iota \sigma \tau o \varsigma$

10+8+200+70+400+200+600+100+10+200+300+70+200

2368

It appears as if the rays of the sun represent God's love, coming from Him to his human family, through the Lord Jesus Christ. And was it not John who wrote those oft-quoted words:

For God so loved the world that he gave his only begotten Son, that whosoever believeth in him should not perish, but have everlasting life. (John 3:16)

Yes it was love. It was His love for His human family that moved Him to offer His only Son, Jesus Christ, to pay the price for Adam's sin, and thereby give the entire race an opportunity for life. That precious love is, in the New Testament, called *agape.* It is a love that expresses

the nature of the one doing the loving, regardless of the sinful nature of the one who receives it. That love is expressed in the 93 million miles light travels from the sun (Him) to the earth (his human family). How fitting that the Gematria value of *agape* is 93.

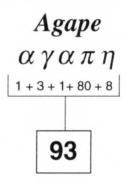

Agape

$$\alpha\ \gamma\ \alpha\ \pi\ \eta$$

$$1 + 3 + 1 + 80 + 8$$

93

That divine love comes down as rain upon the vast surface of Lake Victoria, and flows out, into the Great Rift as the Nile.

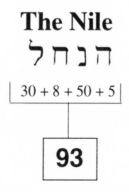

The Nile

הנחל

$$30 + 8 + 50 + 5$$

93

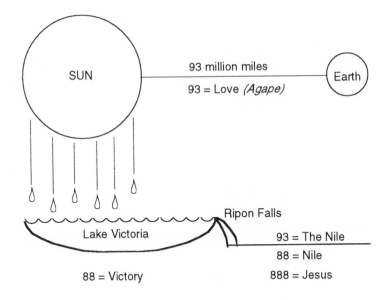

The love of God, as pictured in the sunlight that engulfs our earth, and the rain that gently falls on Lake Victoria, has been indelibly engraved in the ceaseless flow of the river. Its never-failing waters refresh and heal the lifeless desert sand.

The lake and the river bear the numbers that speak of divine love for mankind – a love that compelled Him to send his own Son to be man's Redeemer. The numbers tell the story:

93 = Love *(Agape)*
93 = The Nile
88 = Victory
88 = A son is given (Isaiah 9:6)
888 = Jesus

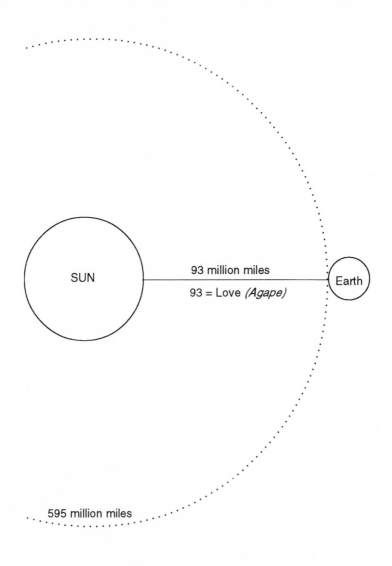

The earth, in its annual orbit of the sun, travels 595 million miles. If we draw this distance out on a straight line, and determine the time it would take for light to

traverse its length, the result would be 888 hours. (A decimal occurs in this figure but the Gematria numbers disregard decimals and zeros.)

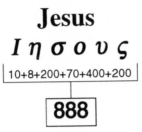

Jesus

$$I\ \eta\ \sigma\ o\ \upsilon\ \varsigma$$

10+8+200+70+400+200

888

595 million miles ÷ 186 = 3198924.7 seconds
3198924.7 seconds ÷ 60 = 53315.4 minutes
53315.4 minutes ÷ 60 = 888 hours

The flow of the Nile never ceases. It is an abundant, ever available river, supplying life to all who dwell along its banks. From its source at Lake Victoria it descends over many waterfalls and through many cataracts until this magnificent abundance reaches the Delta, where it deposits its rich nutrients as it flows peacefully toward the Mediterranean.

From Lake Victoria to the Delta it has descended a height of 4,000 feet and traveled 4,000 river miles. It does not go unnoticed that the years of man, from the sin of Adam to the death of Jesus (the second Adam) are known to be 4,000 years.

Beside the mouth of the river, as it enters the Delta, the Great Pyramid keeps its silent vigil – a magnificent "sign" and "wonder" in the land of Egypt.

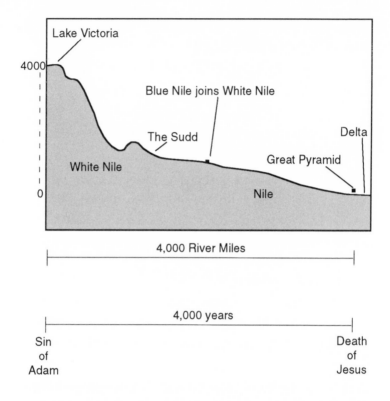

In the science of Gematria (number substitution for the alphabet), the letter *delta* in Greek bears the number 4 because it is the fourth letter of the alphabet. It is fitting that the 4,000-year mark, as well as the 4,000-mile mark not only define the beginning of the delta, but also the site of the Great Pyramid. The Greek letter *delta*, when written as a capital, is a pyramid – Δ.

The topstone of the Gread Pyramid, although it has never been found, is also the same pyramid shape as the rest of the structure. The prophet Isaiah referred to this

topstone as a symbol of the Messiah. The phrase he used has a Gematria value of 400.

400 = "Behold I lay in Zion a Stone" (Isaiah 28:16)

The Apostle Peter quoted this phrase from Isaiah, and applied it to Jesus.

> ... ye have tasted that the Lord is gracious, to whom coming, as unto a living stone, disallowed indeed of men, but chosen of God, and precious ... Wherefore also it is contained in the scripture, "Behold, I lay in Sion a chief corner stone, elect, precious..." (I Peter 2:3-6)

Thus Jesus is the *delta* stone – who bears the number 4, placed at the end of 4,000 years of time; at the end of 4,000 river miles; and at the bottom of 4,000 feet of descent of the Nile. And how fitting that Peter called this *delta*-shaped stone a *"living stone."* It has been suggested in the previous chapter that Dr. David Livingstone (Living-stone), in some ways, represented Jesus.

The *delta* symbol, the Great Pyramid, tells the story of the salvation of man through the offering of the human life of Jesus Christ. Its passages, chambers and measures all illustrate that wonderful story. It is not a simple coincidence that this magnificent structure has been placed at the head of the Delta of the Nile. It appears to be the "gate" through which all mankind will experience the promises of earth's great Millennium, represented by the Nile Delta, the most fertile land on the face of the earth. It has all the

all the evidence of being of divine design.

The length, the shape, the flow, and the placement of the Nile, also speak loudly of divine design. Perhaps they both are parts of one grand picture, traced by the finger of God and etched into the desert of Egypt, to be an everlasting witness – a testimony of divine love for the human family.

The expression of that love began as a promise. The river became the promise written in sand.

The river begins with rain falling on the surface of Lake Victoria. It ends at Cairo and the Great Pyramid, where it fans out into its delta. The name Cairo is from *Al Qahirah,* meaning "victorious." Thus the river bears the name of "victory" at both ends. And indeed it tells the story of victory – a story in which every man who ever lived will play a part.

But if we say the name "Cairo" as we pronounce it in English, it sounds the same as the Greek word *kairos,* which means "time." And it is indeed a river of time.

The equator, 0°, which lies near the north end of Lake Victoria, suggests the concept of "beginning." Perhaps it equates with the creation of Adam, as that was indeed the beginning and the birthplace of God's human family. The only outflow from the lake is at Ripon Falls, where the water plunges down into the Great Rift. This is at 0.4° N latitude. Thus we see the number 4 which denotes "judgment," occurring at the south end of the river, counterbalanced at the north end of the river by the number 4 *(delta),* which again denotes judgment. But Isaiah prophesied that

Isaiah prophesied that *"When the judgments of the Lord are in the earth, the inhabitants of the world will learn righteousness."* (Isaiah 26:9) This is the whole purpose of the Millennium – that the inhabitants of the world will learn righteousness.

The Great Rift symbolizes the great rift that occurred between God and his human son, Adam, resulting in an estrangement and loss of sonship. But Victoria –"victory" – plunges into the Great Rift, with its promise of recovery. This promise was first indicated when God rebuked the "serpent" who had deceived Eve. He said,

> *I will put enmity between thee and the woman, and between thy seed and her seed; and it shall bruise thy head, and thou shalt bruise his heel.* (Genesis 3:15)

The *"her seed"* mentioned here is a first reference to the promised *"seed"* who would bless all the families of the earth, namely Jesus Christ. Two thousand years later a similar promise would be given to Abraham:

> *In thy seed shall all the families of the earth be blessed.* (Genesis 12:3 and 28:14)

This, too, is pictured by the river, but we'll get to it downstream.

Eve probably thought that her first child was the promised *"seed,"* for she named him Cain, saying, *"I have gotten a man from the Lord."* However, Cain caused the first human death, after which a son of promise was indeed born, and she called his name Seth, which means *"substituted."* He was a picture of the promised seed who

would also be a substitute – a substitute for Adam, taking his place in death. The Gematria value of Seth is 700. It is a subtle reminder that the One whom he pictured, Jesus Christ, would be a perfect man – the number 7 is used consistently in the scriptures to represent perfection.

After plunging down into the Great Rift, the river slows into Lake Kyoga where its waters spread. Comparing the river miles with the flow of time, this would be about the time of the birth of Seth. With the birth of Seth's son, the scripture says *"Then men began to call upon the name of the Lord."* Some say this should be translated, *"Then men began to call themselves by the name of the Lord."* Either way, it indicates a time when men recognized God and wanted to be part of His family.

The river flows gently through Lake Kyoga and out into rugged rapids and steep descent. Eventually plunging over Murchison Falls before entering the north end of Lake Albert. This portion of the river, from Lake Victoria to Lake Albert, is called the Victoria Nile.

It enters Lake Albert – part of the Great Rift – from the northeast, flowing out again to the north in what is called the Albert Nile. From there it tumbles downward through the rugged mountains of Uganda, and eventually reaches the plain, where it slows and loses its identity in the vast swamps of the Sudd. Its entrance into the swamps, in river miles, brings us in time approximately to the death of Adam. From there the river is seemingly lost.

The Sudd was the great obstacle that prevented the explorers from simply traveling upstream to find the

source of the river. It was, and is, impenetrable. It is the most formidable swamp in the world. The Nile completely loses itself in a vast sea of papyrus ferns and rotting vegetation. Crocodiles and hippopotamuses inhabit its muddy water, while mosquitoes and other insects choke the air. It is neither land nor water. The floating vegetation gradually builds up into large solid chunks as much as twenty feet thick and strong enough for an elephant to walk on. These dissolve and reform in another place, and this is repeated thousands and thousands of times in patterns that go on forever. The river itself simply disappears into a spongy mass of vegetation.

For a small swamp, this would pose no big problem, however, the Sudd covers an area about the size of England. Through its vast interior the river simply loses its identity and seemingly disappears.

In river miles, it appears to cover the period of time prior to the birth of Noah, when disobedient angels intermarried with the daughters of men and produced a hybrid race. The Bible tells us that during this time evil and wickedness prevailed.

> *There were giants in the earth in those days; and also after that, when the sons of God (angels) came in unto the daughters of men, and they bare children to them, the same became mighty men which were of old, men of renown. And God saw that the wickedness of man was great in the earth, and that every imagination of the thoughts of his heart was only evil continually.* (Genesis 6:4-5)

The Sudd, sucking up the river into its webb of confusion, takes on the appearance of a delta.

The Greek letter delta, Δ, has a Gematria value of 4. It is the number that indicates judgment. And indeed judgment came upon that hyhrid race and their angelic

fathers. In the book of Jude we find evidence of a judgment to come because of their disobedience.

The angels which kept not their first estate, but left their own habitation, he hath reserved in everlasting (age-lasting) chains under darkness unto the judgment of the great day. (Jude 6)

This statement by Jude seems to imply that those angels which materialized as humans and took the daughters of men for their mates, will receive judgment in the "great day," which is probably the Millennium.

Judgment is pictured in the *delta* shape of the Sudd, and judgment is pictured in the *delta* shape of the real Delta at the mouth of the Nile. Can a river have two deltas? No. But it appears so with this river.

A delta only forms where a river flows into the sea. Or it will sometimes appear to form where a river is swallowed up by a desert and simply disappears, but this is still at the end of a river. A delta does not form in the middle of the flow. Yet, the Sudd appears to defy these laws of physics. What is happening here? Could it possibly picture a pseudo-great-day? If so, how and why?

We do not know the motivation of those angels who *"kept not their first estate."* The Bible tells us their offspring were evil in the extreme. They were a hybrid and unauthorized people. But the angels who fathered them were not necessarily evil. One theory suggests they had good intentions, and came for the purpose of uplifting mankind out of the Adamic curse which they were under.

If this theory be correct, it is possible that such an

attempt would, if successful, supplant the work of earth's great Millennium, and rescue mankind out of the depths to which they had fallen. Perhaps it could explain why the Sudd looks like the real Delta.

The fact remains, the Nile disappears into the Sudd. Oh, it's still there, but indistinguishable as a river, or as a navigable waterway. The river represents the promise of life through Jesus Christ. This hope of life was so deeply obscured during the time when the hybrid race was upon the earth, that it seemed to be non-existent.

But God raised up a man whose lineage had not been contaminated with the angelic stock. His name was Noah. The name means "rest." It is spelled נח, having a Gematria value of 58. These same two Hebrew letters, when reversed, spell the word חן, meaning grace or favor, and of course, having the same number value of 58.

The study of the number values of the Hebrew words uncovers some true gems. The prophet Ezekiel used this same number when he spoke of the time when God's human family will truly experience rest. He called it "showers of blessing," which has a Gematria value of 58.

> *I will set up one shepherd over them, and he shall feed them, even my servant David* (Jesus, the antitypical David); *he shall feed them, and he shall be their shepherd. And I the Lord will be their God, and my servant David* (Jesus) *a prince among them; I the Lord have spoken it. And I will make with them a covenant of peace ... and I will make them and the places round*

about my hill (kingdom) *a blessing; and I will cause the shower to come down in his season; there shall be showers of blessing.* (Ezekiel 34:23-26)

58 = Noah
58 = Grace (favor)
58 = Showers of blessing

The "showers" that came down in Noah's day surely do not sound like showers of blessing, for they wiped out all those who had not taken refuge in the ark. Yet the end result was "rest" and "blessing." Just so, the river appears again beyond the Sudd, flowing in its northward course, toward the real Delta and the Mediterranean.

With the re-appearance of the river, it is joined by the Sobat, a tributary flowing in from the east, bringing a change in color to its waters. White clay, suspended in the waters of the Sobat, spread out into the river, giving it a white shade. From the Sobat northward the river is called the White Nile. White is a symbol of righteousness. It seems to speak of the righteousness of Noah and the beginning again of righteousness in God's human family.

The river continues its northward journey as the White Nile until it reaches Khartoum, where it is joined from the east by the Blue Nile. From there, northward, it is called Nile. The city of Khartoum can rightly be called the edge of the desert. As can be seen on the map, the general dividing line between the vegetation and the desert

is at 15.6° north. The name Khartoum means *elephant trunk*, because the land at the confluence is shaped like one.

From Khartoum northward, the river cuts its way through more than 1,600 miles of desert – a desert that does not swallow the precious river, but gives it passage in return for the life that it brings.

Khartoum marks a very special place in the flow of the river. It is from this point northward that the inflow of the waters of the Blue Nile enrich the river and its surrounding lands as it deposits its mineral-rich silt along its banks, finally reaching the Delta where it plants its remaining silt, producing the most fertile land on the face of our planet. This life-giving feature of the river comes mainly from the Blue Nile in flood season.

It has been said that the source of the Nile is Lake Victoria, via the White Nile in the dry season, but is Lake Tana via the Blue Nile in flood season. Averaging the flow over a year's time, the Blue Nile furnishes 58% of the water in the Nile. So which lake is the true source of the Nile? They both are! But the Blue Nile exceeds the White Nile by the number 8 – the number of New Beginning.

Lake Tana lies high in the mountains of Ethiopia, 6,000 feet above the Nile Delta. Its center is 12° N and 37° E. It is heart-shaped. Those who have flown over it say it looks like a beautiful blue valentine below. And perhaps it is.

Heart-shaped Lake Tana,
the Blue Valentine

A valentine expresses love. The color blue, in the Bible, represents faithfulness. Perhaps heart-shaped Lake Tana lies there, reflecting the deep blue of the sky, as a symbol of God's love and His faithfulness – the heart of

God. The lake covers an area of 1,200 square miles. The number 12, in Bible symbology, is the "foundation" number. It represents the very nature of God Himself, and is the foundation of all creation. In the Gematria code of the Bible, the word "foundation" bears the number 12; it also bears the number 74. These numbers are basic to creation.

120 = Foundation, מוסדי
74 = Foundation, יסד

A most remarkable fact occurs when we multiply 12 times 74. The product is 888, which is the Gematria value for Jesus. Using the same two numbers, add them, and the total will be 86, which is the Gematria value for God, *Elohim.* Thus both the Father and the Son are the foundation of creation. And this is what the Apostle John said in the first verse of his gospel.

> *In the beginning was the Word, and the Word was with God, and the Word was God. The same was in the beginning with God. All things were made by him; and without him was not anything made..."* (John 1:1-3)

12 x 74 = 888 = Jesus, *Ιησους*

12 + 74 = 86 = God, אלהים

The concept of "foundation," "creation," and "eternity" are linked in such a beautiful way that we marvel at the wisdom of God in encoding these into His Holy Word, as confirmation to us that He is indeed the Creator, and that His plan for man is the *"work of His hands."*

It is difficult for us to comprehend that which is perfect, or that which is eternal. But the illustration given to us in the scriptures is that of a perfect circle. Note how the numbers below combine and define these concepts.

740 = Creation, κτισις

74 = Eternity, עד

74 = Foundation, יסד

740 = You have laid the foundation of the earth, הארץ יסדת, (Psalm 102:25)

74 = Circle (circuit), סביב

740 = Circle, κυκλος

120 = Foundation, מוסדי

120 = Perfection, מכלל

12 = Love, חבב

Lake Tana, the "blue valentine" is a beautiful representation of the love of God, and His faithfulness in all that He has promised to His human family. That love was expressed in the sending of His only Son to pay the price (death) for the sin of Adam, and thereby giving all of Adam's children the opportunity to obtain life. No greater love can there be found!

Heart-shaped Lake Tana was known to the ancient historian, Strabo. In 22 B.C. he wrote of the lake, and called it *Psebo*, for this was its Greek name. It was thrilling for me to realize that *Psebo* has a Gematria value of 777. And we have seen previously, with the exploration of Lake Victoria, that the number 777 is the Gematria value for "Love of God." The ship that Henry Morton Stanley used, in which 12 men set sail to circumnavigate Lake Victoria, was named "Lady Alice," which we saw also had a Gematria value of 777. And the number 12 appears here at Lake Tana by the 12 hundred square miles of its surface area.

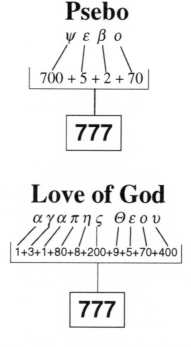

Psebo

$\psi \, \varepsilon \, \beta \, o$

$700 + 5 + 2 + 70$

777

Love of God

$\alpha \gamma \alpha \pi \eta \varsigma \; \Theta \varepsilon o \upsilon$

$1+3+1+80+8+200+9+5+70+400$

777

Lady Alice

$$\kappa\,\upsilon\,\rho\,\iota\,\alpha\quad \alpha\,\lambda\,\iota\,\sigma\,\varepsilon$$

$$20+400+100+10+1+1+30+10+200+5$$

777

It is exciting indeed to observe the way our Creator has encoded His word and His creation to illustrate this great love. It is the central theme in all His works. He sent us a "blue valentine." Let's read its message.

Lake Tana is heart-shaped. In the Gematria of the Hebrew scriptures, "heart" has a number value of 37. This highest lake in Africa has exactly 37 islands. These islands have housed monasteries since ancient times. Tradition says the Ark of the Covenant was hidden on one of the 37 islands during a time when the town of Axum was under siege. (Axum is where the Ark of the Covenant now resides. Whether it is the original Ark of the Covenant or a replica depends upon who is telling the story.)

We have just observed the fact that the number 74 denotes the "foundation" of creation. If the number 74 represents the shape of the heart, each side of the heart would bear the number 37. And 37° E longitude divides the lake at its center. As shown previously, the numbers 3 and 7 are the basic numbers of creation – 3 being the first number with shape, and 7 being perfection. The work of creation as stated in Genesis 1:1 has a Gematria value of 37 x 73.

37° E

Left side – 37 = God, אלהא
Right side – 37 = Only Son, היחיד

74 = Foundation, יסד

The yearly flow from Lake Tana provides 58% of the water in the Nile. It is the flow that comes from the *"heart of God."* How thrilling to find the Gematria for *"heart of God,"* לב יהוה, to be 58. Probably not a coincidence. It tells us that all the water flowing in the Blue Nile comes from the heart of God, as represented by Lake Tana.

> **58 = Heart of God,** לב יהוה

The "blue valentine" from which flows the mighty river of life provides some striking Gematria. They are certainly not random numbers; but have all the appearance of being part of the original plan.

37 = The heart, הלב

370 = Perfect, שלם

370 = Peace, שלם

37 = Foundation of the earth, יסרה ארץ, (Isaiah 48:13)

370 = He hath founded the earth, ארץ יסרה, (Amos 9:6)

37 = God, אלהא

37 = Only Son, היחיד

37 = Only begotten, יחידה

370 = My Anointed (Messiah), במשיחי, (Psalm 105:15)

It is a striking observation to realize that each half of the heart shape is, in fact, a Golden Spiral. This shape is based upon one of the foundation principles of creation – the Golden Proportion. Physicists have found this proportion to be a "physical constant" involved in the growth principle of all matter. It is sometimes called the "growth constant." Mathematically it is written as .618 or 1:1.618. The Gematria of the Bible uses both.

618 = God, the God of Israel (Genesis 33:20)

618 = He is the God of gods and the Lord of lords, God the great, the mighty (Deuteronomy 10:17)

618 = I am the first (Isaiah 48:12)

2 x 618 = God with us (the name Immanuel, given to Jesus.) (Matthew 1:23)

The relationship of this Golden Proportion, and its beautiful spiral, is to be found in the shape of Lake Tana, the heart of God. To see this relationship, let's first

observe the Golden Rectangle and the formation of its amazing spiral.

Each time a Golden Rectangle is portioned off with a square, the remainder becomes another, and smaller, Golden Rectangle. This actually continues to infinity, but to show the Spiral, it is divided into only 8 squares. By connecting the corners of each square with the quadrant of a circle, the Spiral appears.

If the long side of the above Golden Rectangle measured 37 units, the spiral would measure 88.8 units. This amazing math shows the inseparable relationship of the

number 37 with the name of Jesus, which bears the number 888.

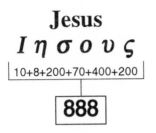

Jesus

I η σ ο υ ς

10+8+200+70+400+200

888

The rectangle grows by adding a square to its long side. This square would have a perimeter of 148 units.

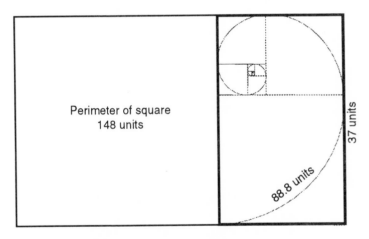

Perimeter of square
148 units

37 units

88.8 units

1480 = Christ, *Χριστος*
1480 = Son of God, *υιος Κυριος*

An amazing reality becomes apparent when we place two of these Golden Spirals tangent to each other, as mirror opposites. They define a heart shape, having two spirals, each with a length of 88.8.

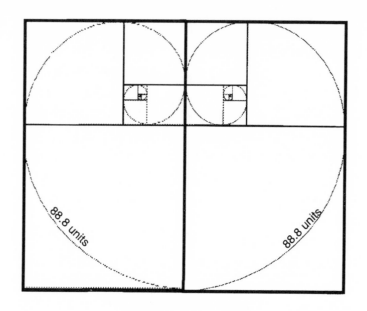

$$\begin{array}{r} 888 = \text{Jesus} \\ + \ 888 = \text{Jesus} \\ \hline 1776 \end{array}$$

1776 = River of Life

"And he showed me a pure river of water of life, clear as crystal, proceeding out of the throne of God and of the Lamb." Revelation 22:1

Indeed, a river of life flows from heart-shaped Lake Tana, just as the River of Life flows from the heart of God! It was His plan from the beginning to give His

human family this water of life. Adam possessed it at the time he was created, but lost it when he sinned. Jesus purchased it back again. The final chapter of the Bible tells us that all mankind will have the River of Life restored to them when God's plan for their redemption and restoration is complete.

The river flowing south from Lake Tana is the Blue Nile. At 18.6 miles from the south end of the lake, the river plunges over the 144-foot basalt cliff at Tississat Falls. A rumble of sound fills the air, and the ground seems to tremble with the force and strength of the water. Its 144-foot fall into the rocky chasm below sends up a continuous mist that drenches the surrounding countryside, producing continual rainbows that shimmer across the gorge under the changing arc of the sun. The pillar of cloud in the sky above, seen from afar, gives the falls its name – Tississat, meaning "water that smokes."

Here the Blue Nile falls into the Great Rift. Just as Lake Victoria is not part of the Great Rift, yet its waters flow northward down into the Rift, so the waters from Lake Tana, flowing south, plunge into the Great Rift at 18.6 miles south of the lake. It is a figure that speaks loudly of the offering of Jesus as the promise of life for all of Adam's race.

The number 186 primarily refers to Jesus, as the light of the world – 186,000 mps being the speed of light. This is confirmed by the Gematria pertaining to His offering of Himself on a hill named Golgotha, which has a number value of 186. On the afternoon of the "day that changed

the world," at 3:01 Jerusalem time Jesus uttered His last words, *"It is finished."* This phrase is from the Greek word, *γεγονεν,* having a number value of 186. He had finished the offering of His human life as a substitute for the life of Adam.

At 3:01 U.T. that afternoon, the moon began to eclipse.

This turning point in human history took place on a hill called Golgotha. But it had another name. It was also called Calvary, which is from the Greek word *κρανιον*. It means "the place of the skull" – so named for the skull-like rock formations on its side. Calvary has a number value of 301.

Again the Golden Proportion reveals the beauty of the numbers. Divide 186 by the Golden Proportion – .618 – and the result is 301.

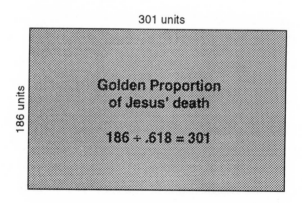

301 units

186 units

Golden Proportion
of Jesus' death

186 ÷ .618 = 301

186 = Golgotha, *γολγοθα*
301 = Calvary, *κρανιον*

The river, flowing southward out of Lake Tana, figuratively restores the right-to-life to Adam. It becomes a river of life. Just as Lake Victoria pictured the "victory" that was purchased for Adam from the beginning – before Adam needed it – so Lake Tana pictures the same provision that was in the heart of God from the beginning. It is the outflow from His heart – the expression of His love.

At 18.6 miles south of the lake, it thunders over the escarpment and into the rocky gorge below. The Golden Proportion marks this point with the numbers 186 and 301. It is the Gematria value for the expression used in Zechariah 9:10, *"From the river."*

301 = From the river, רמנהר

Zechariah was prophesying regarding the time when this event would actually take place, at the first advent of Jesus. The river, as it flows southward from Lake Tana prophesies of the provision for this as it was planned in the heart of God from the beginning. But let's read Zechariah's prophecy.

> *Rejoice greatly, O daughter of Zion; shout O daughter of Jerusalem: behold, thy King cometh unto thee: he is just, and having salvation; lowly, and riding upon an ass, and upon a colt the foal of an ass.... His dominion shall be from sea even to sea, and from the river even to the ends of the earth.* (Zechariah 9:9-10)

Why *"from the river?"* What river? It is, of course, pictorial language; and the picture from which it is drawn is the promise written in sand. The "river" is the Nile, having its beginnings in both Lake Victoria and Lake Tana. But it is the Blue Nile, coming out of Lake Tana that gives the river its "life."

Long before the river reaches Tississat Falls, the pillar of cloud can be seen rising above the falls, and the roar of its waters permeates the air. Whatever the time of day, the rainbow can always be seen shimmering through the white mist, disappearing into the depths of the roaring waters. It reminds us of another rainbow that filled the sky – the rainbow which Noah saw as he opened the door of the ark and emerged into the flood-drenched earth. That beautiful rainbow was a promise from God.

> *And God spoke to Noah, and to his sons with him, saying, And I, behold, I establish my covenant with you and with your seed after you; and with every living creature that is with you I will establish my covenant with you; neither shall all flesh be cut off any more by the waters of a flood; neither shall there any more be a flood to destroy the earth. And God said, This is the token of the covenant which I make between me and you and every living creature that is with you, for perpetual generations: I do set my bow in the cloud, and it shall be for a token of a covenant between me and the earth."*
> (Genesis 9:8-13)

The covenant was with righteous Noah. It promised that never again would a flood destroy the earth and its inhabitants. But the covenant did not promise life to the human family. It took another covenant and the shedding of blood for its fullness.

Tississat Falls spreads out across the escarpment as it drops 144 feet into the gorge below. There it regroups and is funneled into a second, shorter falls, pouring all the water through its narrow walls. Perhaps this lower falls is a representation of the Covenant with Abraham, in which God promised to bless *"all the families of the earth."* It is all-inclusive. No one is left out.

Through these two covenants, the human family has the assurance that the earth will abide forever as man's home, and God's human family will receive His blessing of everlasting life. It was the Creator's original intent, and it will be His ultimate reality.

Perhaps the 144-foot fall is a representation of the everlastingness of the covenant with Noah. The Hebrew word *kedem*, קדם, has a number value of 144. It is translated *"everlasting."* The Hebrew word *kedem* literally means "that which has no beginning nor ending – everlasting." And surely, God promised that never again unto all eternity will He ever destroy the earth with a flood. The 144-foot fall appears to be the reassurance and confirmation of the promise.

Downstream from the falls, the river races wildly through the rugged gorge. In places the gorge is 4,000 feet deep, and so forbidding that even local people are

afraid to go there. In places it narrows between steep cliffs which shut out the sun, its silt-laden waters grinding and tearing their way through the deep canyons. The river first flows southeast, then curves around in a southward direction, then westerly, and eventually northwest, reaching the White Nile at Khartoum at about 3.7˚ above its starting place at the south end of Lake Tana.

At Khartoum the inflow of the Blue Nile dominates the scene, sometimes even holding back the waters of the

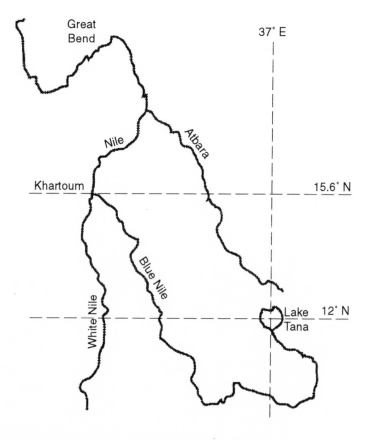

White Nile, while it pours its muddy brown water into the main stream of the Nile. The river has come 1,008 miles from its source in Lake Tana.

For one who studies the Gematria of the Bible, this figure of 1008 incites the mind to investigation. It is one of the sacred numbers in the patterns of scriptural Gematria. And a magnificent one! So – what is it doing here, in the linear measure of the Blue Nile?

The first thing that comes to mind is Psalm 8. Its use of this number carries meaning beyond our comprehension.

> *O Lord, our Lord, how excellent is thy name in all the earth; who hast set thy glory above the heavens ... When I consider thy heavens,* <u>*the work of thy fingers,*</u> *the moon and the stars, which thou hast ordained; what is man, that thou art mindful of him, and the son of man, that thou visitest him? For thou has made him a little lower than the angels, and hast crowned him with glory and honour. Thou madest him to have dominion over the works of thy hands; thou hast put all things under his feet."* (Psalm 8: 1-6)

Here the Psalmist is comparing the majesty of the Creator with the smallness of man, yet acknowledging the marvelous privilege that has been given to man to have *"dominion"* of the earth. A dominion, which sadly, man has corrupted. A dominion, which however, will be restored to man through the redemptive work of Jesus Christ.

In this Psalm, the words *"the work of thy fingers"* has a Gematria value of 1008.

1008 = The work of thy fingers

The work of God's hands, pertaining to man, is the earth – man's home. Our moon is part of that unit, as together they orbit the sun. It is worthy of our note that the combined mean diameters of earth and its moon add to 10,080 miles.

It appears that the 1,008 miles of the Blue Nile represent the means of the complete restoration of man's

dominion, bringing its life-sustaining nutrients to a thirsty world. This comes by means of the Covenant with Abraham that through his "seed" (Christ), all the families of the earth will be blessed.

As the mineral-rich waters of the Blue Nile flow into the Nile at Khartoum, they bring life to the barren deserts of Sudan and Egypt. The borders of the river, being fed by the rich silt-laden waters, becomes the "bread basket" of an otherwise hungry land.

The 1,008 miles of the Blue Nile relate to this life-sustaining *"bread"* by the Gematria of the *"bread from heaven"* that was provided for the Israelites during their journey through the wilderness. That bread, of course, was a picture of the real *"Bread of Life"* – Jesus Christ.

1008 = This is the bread which the Lord hath given you to eat. (Exodus 16:15)

When, in the course of time, the One who would be that living bread came to earth, an angel made the announcement to Mary, *"He shall be great, and shall be called the Son of the Highest, and the Lord God shall give Him the throne of David."* (Luke 1:32) It has a Gematria value of 10080, identifying Him with the life-giving bread.

At Khartoum the two rivers come together at a latitude of 15.6°, which is slightly over the halfway point, as the crow flies, between Lake Victoria and the Great Pyramid, where the river fans out into its Delta. If we consid-

ered the total distance of the Nile as 4,000 years, Khartoum would be positioned at 2,093 years. It is not surprising to find that 2,093 years from the sin of Adam brings us to the year of the Covenant with Abraham. The inflow of the Blue Nile at this latitude is confirmation that it represents the Covenant – the Covenant that brought the promise of life to *"all the families of the earth."*

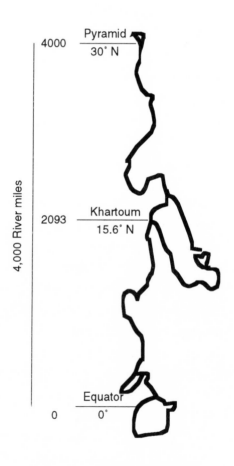

At the confluence of the rivers the edge of the desert begins. This means there is little or no rain. All the water for growing their crops must come from the river. The land from there to the Mediterranean, including the Delta, receives no rain. The river is its only source of life. At Atbara, about 200 miles downstream, the yearly rainfall is 0.

The Atbara river is the only other major tributary supplying water for the Nile. It rises in the Ethiopian highlands, not far from Lake Tana. On some maps it appears to flow from the lake, but when examined closely, it can be seen that it does not. In summer the river can swell to a thousand feet wide with rainwater from the highlands, but in winter it becomes a mere trickle, and sometimes stops entirely. With this final contribution, the Ethiopian highlands give 86% of the water that reaches Egypt.

Since it is apparent that the two covenants, Noahic and Abrahamic, were represented in the flow of the Blue Nile, it might be suggested that the Mosaic covenant could be represented by the Atbara. It was a marriage covenant between God and Israel; the keeping of it would have brought abundant blessing.

> *If ye walk in my statutes, and keep my commandments, and do them; then I will give you rain in due season, and the land shall yield her increase, and the trees of the field shall yield their fruit. And your threshing shall reach unto the vintage, and the vintage shall reach unto the sowing time: and ye shall eat your bread to*

the full, and dwell in your land safely. And I will give peace in the land, and ye shall lie down and none shall make you afraid." (Leviticus 26:3-6)

History tells us that Israel, although they agreed to keep the Law that was given to Moses, in reality did not keep it. Whereas it could have brought them abundant blessing, it became a death sentence to them. Thus the Atbara dries up in the winter months and does not supply the Nile with water. And even in the months of its flow, it does not bring nutrients into the Nile.

The Atbara joins the Nile at 17.6° North. And, although Israel was unable to keep the Law given through Moses, nevertheless it was to be a valid covenant until "Shiloh" would come.

1760 = The sceptre shall not depart from Judah nor a lawgiver from between his feet until Shiloh comes. (Genesis 49:10)

This prophecy is primarily a promise concerning the return of Jesus at his second advent, when he comes as King upon David's throne, yet, for Israel under the Law, it had an application at His first advent. Because of their failure to keep the Law of Moses, and because they failed to recognize "Shiloh" when he came to them, that Law Covenant was put to an end, and God's marriage to Israel ended in divorce at Calvary.

And so we see the Nile, the river of life, turning and flowing south soon after the confluence with the Atbara. It is called the Great Bend. Its flow northward, toward God, is impeded by Israel's disobedience.

Herodotus, in the 5th century B.C. had attempted to find the source of the Nile. He traveled from Cairo upstream. His logical assumption was, of course, that it would lead him to the source. However, upon reaching the first cataract his forward progress was permanently stopped. For him, it became an impossible task to travel around the falls.

That first cataract came to be known as Aswan. It is listed on our maps as the "first cataract" although, as the river flows, it is the last one. From there the river flows peacefully to the Delta.

At this "first cataract" the water is forced between narrow walls, and plunges through the gorge with seemingly never-ending power. That is, until a dam was built there.

The city of Aswan has existed for more than 4,000 years. Its location on the Nile made it the convenient "market" for African products. Thus Aswan means "market." Its name comes from the red granite which was quarried there, called Sianite, used in the construction of the Great Pyramid. The city is at the northern part of the Nubian desert – Nubia meaning "Land of Gold." Aswan was, and is, known as the "Gateway to Africa."

We would think that Herodotus did not get very far,

and as compared to the whole river, perhaps he did not. However, for his day it was a long journey indeed – for Aswan is 666 miles from Giza. For a person who studies the Gematria of the Bible, of course the number 666 stirred my interest, as well as did many other of the numbers.

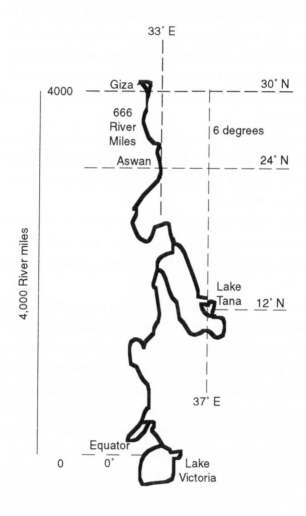

Aswan, in fact, is located at a very interesting position on the face of our earth. It is 24° N latitude and 33° E longitude. If we were to consider the number of degrees from Lake Tana to Giza (18°) as representing 6,000 years of man's history, we find Aswan sitting at precisely 4,000 years, or the time of the death of Jesus.

The reason for suggesting this representation of 6,000 years is because the actual fall of the river is 6,000 feet from Lake Tana to Giza. As it passes through the cataract at Aswan, it marks the 4,000-year point on the latitude scale.

Perhaps this "first cataract" (which is really the last one) represents He who called Himself the *"first and the last, the Alpha and the Omega."* (Revelation 1:11) If so, we can take another look at the meaning of the name Aswan.

"Market" – "Land of Gold":

> *"I counsel thee to buy of me gold tried in the fire,"* (Revelation 3:18) *"And let him that is athirst come. And whosoever will, let him take the water of life freely* (without cost)." (Revelation 22:17) *"Ho, every one that thirsteth, come ye to the waters, and he that hath no money; come ye, buy, and eat; yea, come, buy wine and milk without money and without price."* (Isaiah 55:1)

The Apostle Paul told us about the *"free gift"* in his letter to the Romans. He said,

Therefore as by the offence of one, judgment came upon all men to condemnation; even so by the righteousness of one the free gift came upon all men unto justification of life. For as by one man's (Adam's) *disobedience many were made sinners, so by the obedience of one* (Jesus) *shall many be made righteous.* (Romans 5:18-19)

It is for this reason I suggest Aswan could represent the "Market" or place where we buy life without money and without price – it is a free gift provided by Jesus Christ. The word "market" in Hebrew has a number value of 312 and so does the word "gift." We don't think of a gift as something we buy in the market, but the scriptures indeed express it in this way.

Market

מ ע ר ב

| 2 + 200 + 70 + 40 |

312

Gift

שׁ ח ד

| 4 + 8 + 300 |

312

The Greek text identifies the gift. The word "market" in the Greek New Testament is translated from the word αγορα *(agora)*. It has a number value of 175.

Market

Lord of lords

Jesus Christ, as the "gift of life" is represented by Aswan. It is at this first (or last) cataract on the Nile that the waters surge through the "gate" and out into the peaceful life-giving river that flows 666 miles to Giza, and 180 miles further to the Mediterranean.

Herodotus could not get past this first cataract. Perhaps it is because he knew nothing of the free gift that would be purchased for us by Jesus Christ.

Aswan is sometimes called "the gateway to Africa." It is fitting that Jesus called Himself "the Door." This appellation of "gateway" came as a result of its strategic position on the river, and its function as the market place of Africa.

Its location 666 miles upstream from Giza has a direct connection to the Great Pyramid, which stands at Giza. In Psalm 118:22 is found the statement: *"The stone which the builders refused is become the head stone of the corner."* (The word "stone" here has been supplied by the translators, it is not in the original text.) The text might go unnoticed, except for the fact that Jesus quoted it and applied it to Himself. He is the *"head of the corner."* It has a Gematria value of 666. Jesus, in quoting this verse, was saying that He is represented by the topstone of the Great Pyramid.

But a "topstone" has never been found, and even Herodotus, who saw the Great Pyramid in the 5th century B.C., said it did not have a topstone. This absence of a topstone is obviously what the scripture is saying – *"The stone which the builders refused"* means that they did not put it in its proper place atop the Pyramid.

The prophecy in Psalm 118:22 appears to be saying that this topstone will indeed be placed, and become the *"head of the corner."* Its location 666 miles downstream from Aswan has prophetic significance, as will be discussed in a later chapter.

Aswan is located at 24° N latitude and 33° E longitude. The numbers are full of meaning. The number of

degrees latitude from Lake Tana to Aswan is 12, and the remaining number of degrees to Giza is 6. Finding these numbers in this location is no mere coincidence. It speaks loudly of planning by the One who created the river.

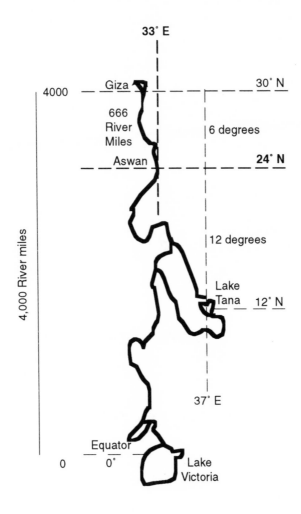

Aswan is positioned at 24° by 33°. The math looks like this: 24 x 33 = 792. Or, if we consider the number of degrees of latitude between Lake Tana and Aswan, the math looks like this: 12 x 33 = 396. Do the numbers 792 and 396 have any relationship to Jesus Christ and the salvation He provided for man? Yes! They are magnificent.

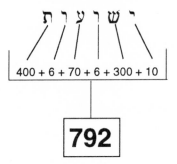

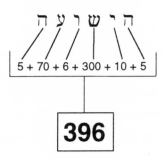

Lord Jesus Christ

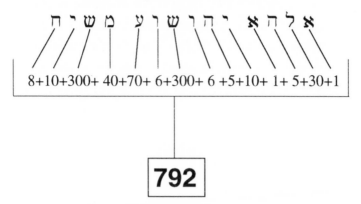

8+10+300+ 40+70+ 6+300+ 6 +5+10+ 1+ 5+30+1

792

The numbers are indeed magnificent. They tell us that salvation comes through the Lord Jesus Christ. And they also tell us that Aswan (24 x 33) is the spot on earth which represents Him and His work of salvation for all the race of Adam. It comes from the heart of God, as is represented by Lake Tana. Indeed *"God so loved the world that He gave His only begotten Son"* to bring us salvation!

In all of His universe, this earth is the only place that needed salvation. These two numbers – 792 and 396 – are numbers that define the dimensions of our earth. And they are the numbers that define salvation through the Lord Jesus Christ. This magnificent display of the Creator's love is shown in the description of creation given to us by the prophet Isaiah. Its Gematria takes my breath away! I'm not often left speechless. Fortunately this demonstration of the magnificent numbers speaks for itself.

Diameter of earth – 7,920 Miles
Radius of earth – 3,960 Miles
Perimeter of square around earth – 31,680 Miles

"... God the Lord, he that created the heavens, and stretched them out; he that spread forth the earth, and that which cometh out of it; he that giveth breath unto the people upon it, and spirit to them that walk therein." (Isaiah 42:5)

This entire verse has a Gematria value of 3168. As can be seen from the illustration above, the entire earth can be put into a box whose perimeter is 31,680 miles. It is indeed no coincidence that this verse of scripture

reveals this exciting number. Exciting? Why? Because it is the number value for the Lord Jesus Christ, as his name is spelled in the Greek text of the New Testament.

Lord Jesus Christ

$$K \upsilon \rho \iota o \varsigma \ I \eta \sigma o \upsilon \varsigma \ X \rho \iota \sigma \tau o \varsigma$$

20+400+100+10+70+200+10+8+200+70+400+200+600+100+10+200+300+70+200

3168

As this verse of scripture in Isaiah 42:5 is broken down into its elements, other exciting numbers appear. It gives us the earth number – 792 – and the number of miles between Aswan and Giza – 666. To reveal the beauty of the text, it should be read in Hebrew. Its translation into English changes the phraseology. Thus the exerpts from this verse, as shown below, are from the word-for-word translation of the Hebrew text.

3168 = God Jehovah, creating the heavens and stretching them out; spreading out the earth and its offspring, giving breath to the people on it and spirit to those walking in it.

792 = God Jehovah, creating the heavens and stretching them out.

792 = and stretching them out, spreading out the earth.

666 = creating the heavens

666 = spreading out the earth

This display of the Gematria of Isaiah 42:5 is telling us the same thing we were told by John: *"All things were made by Him, and without Him was nothing made."*

Isaiah also confirmed these beautiful numbers in his 53rd chapter regarding the "Suffering Servant" – Jesus Christ.

3168 = He shall see the travail of his soul, and shall be satisfied; by his knowledge shall my righteous servant justify many; for he shall bear their iniquities.

792 = He shall see the travail of his soul

The 666 miles from Aswan to Giza brings us to the place where the Great Pyramid is build, and to the beginning of the Delta. The Great Pyramid, as will be discussed in a further chapter, has sometimes been called "The Bible in Stone." It is a representation, in stone, of the plan of God for the salvation of man through Jesus Christ. Its

position at the beginning of the Delta suggests that the remainder of the river – the Delta – represents the results of that salvation that was purchased for man, namely the Millennial Kingdom of Jesus Christ. And so it is fitting that the prophecy of Joel regarding the beginning of that Kingdom of peace should have a Gematria value of 666.

666 = And it will be in that day, the mountains shall drop down new wine (Joel 4:18)

The name Giza means "border" or "edge." It is so named because it is the northern edge of the desert. From there northward the river spreads out into its Delta, providing the most fertile land on earth. The city of Khartoum, where the Blue Nile joins the White Nile, is at the southern edge of the desert. Giza is at 30° N latitude, and Khartoum is at 15.6° N latitude. The number of degrees between these two latitudes is 14.4°. This is about 1,907 river miles, each degree representing about 132 miles.

Khartoum, where the Blue Nile joins the White Nile, is representative of the life-giving promises of the Abrahamic Covenant. God promised Abraham, *"In thee and in thy seed shall all the families of the earth be blessed."* And indeed, the process of blessing all of earth's families through a "seed," presupposes that a Seed would be provided. That Seed was Jesus Christ.

144 = Lord Christ, $\kappa \upsilon \rho \iota o \nu \, \chi \rho \iota \sigma \tau o \nu$ (Acts 2:36)

The 14.4° between Khartoum (Abrahamic Covenant) and Giza (Pyramid location) is the firm promise that indeed a Seed would be provided. But through the grace of God, that seed would be a composite one. The Apostle Paul revealed this in his message to the Galatians.

Now to Abraham and his seed were the promises made. He saith not, and to seeds, as of many; but as of one, and to thy seed, which is Christ.... And if ye be Christ's, then are ye Abraham's seed, and heirs according to the promise. (Galatians 3:16 & 29

It is fitting then, that the number 144 should identify the composite of that seed – the believers.

1440 = Believers, $\pi\iota\sigma\tau\omega\nu$, (I Timothy 4:12)
144 = The elect, $\eta\ \epsilon\kappa\lambda\sigma\gamma\eta$, (Romans 11:17)
1440 = Elect of God, $\epsilon\kappa\lambda\sigma\gamma\eta\nu\ \tau\sigma\upsilon\ \Theta\epsilon\sigma\upsilon$, (Romans 8:17)

The Apostle John, in recording the vision he had been given on the Isle of Patmos, said:

And I looked, and, lo, a Lamb stood on the mount Zion, and with him a hundred and forty and four thousand, having his Father's name written in their foreheads....And they sung a new song before the throne ... and no man could learn that song but the hundred and forty and four thousand, which were redeemed from the earth.... These are they which follow the Lamb whithersoever he goeth. These were redeemed

from among men, being the firstfruits unto God and to the Lamb. (Revelation 14:1-4)

John saw "signs," not realitites. I suggest this "sign" which he saw would represent those believers, the elect, who bear the number 144. They are the composite "Seed" promised to Abraham, through whom all the families of the earth would be blessed. These all (Christ, head and body) were typified in Abraham's literal "seed," which was Isaac.

The 14.4 degrees between Khartoum and Giza involves the promise sworn to Abraham, that through his Seed all the families of the earth would be blessed. The river, indeed, is an illustration of that promise, for it brings life to the barren wilderness – all the way from Khartoum (southern edge of the desert) to Giza (northern edge of the desert).

The river continues to flow from Giza to the Mediterranean, bringing life to the Delta, indeed, creating the Delta. Finally, at 31.4° N latitude, the waters that have come down from Lake Victoria and Lake Tana, over many waterfalls, through six cataracts, and through barren deserts, reach their resting place – the Mediterranean Sea. The life-giving blood of Jesus Christ, represented by the river, will have accomplished its complete work for mankind.

The plan of God for the redemption of fallen man, and the restoration to all that was lost through the disobedience of Adam, will be complete, and will find its final resting place in the Great Sea, which represents eternity.

Then man and his earth will experience fulfillment of the promise given to Abraham, bringing the blessing of life. It will be the fulfillment of the "sign" that John saw on the Isle of Patmos:

> *And he showed me a pure river of water of life, clear as crystal, proceeding out of the throne of God and of the Lamb.* (Revelation 22:1)

When Jesus taught us to pray *"Thy Kingdom come; thy will be done on earth as it is done in heaven"* He was teaching us to prepare our hearts and our desires for His Millennial Kingdom. This much-prayed-for Kingdom is pictured by the amazing Delta.

9

The Amazing Delta

Come, all you who are thirsty, come to the waters; and you who have no money, come, buy and eat! Come, buy wine and milk without money and without cost! (Isaiah 55:1)

It is a beautiful prophecy. Isaiah wrote the words as they were given to him. He did not yet know of similar words that would be given to the Apostle John on the Isle of Patmos some eight hundred years later.

...let him that is athirst come, and whosoever will, let him take the water of life freely. (Revelation 22:17)

But the One who gave the words to them knew, from the beginning, when He reached down with His finger and traced the path of the Nile from the mountains down through the desert sands and into the Great Sea – He knew the pattern; He knew the plan; and He knew from the beginning, the wonderful day when the waters would find their resting place in the Great Sea.

As the life-giving water brought its rich nutrients to the barren land of Egypt, it brought hope and the promise of life. It enriches all who dwell along its banks. And, upon reaching 30° latitude, it fans out into many streams,

depositing the remainder of its wealth in what has become the world's largest Delta and the most fertile land on the face of the earth.

The ancient Egyptians called it Goshen, and gave it to Joseph's family as a gift. However, early geographers, noting its pyramid shape, suggested it looked like the Greek letter *delta* – Δ – and named it accordingly. It has become the prototype for all river deltas.

But there are subtleties tucked away in this fourth letter of the Hebrew and Greek alphabets. The Hebrews called this letter *dalet* – ד – and gave it the meaning of "door." Both *delta* and *dalet* have a Gematria value of 4. We think of a door as opening into something or some place; and in this case it is an open door, leading to the next letter of the Hebrew alphabet, which is *hei* – ה.

The letter *hei* is considered, in both ancient and modern Hebrew, to be the "breath of God." It is equivalent in phonetics to our English letter H, which is spoken by breathing out.

The "door" is open to the left. And since Hebrew is read from right to left, the next letter to the left is the "breath of God." Adding these two letters will result in the number 9, which carries the meaning of fullness, completeness, perfection, fulfillment and finality.

$$ה \quad ד$$
$$5 + 4 = 9$$

The "breath of God" was active in the work of creation. *"By the word of the Lord were the heavens made; and all the host of them by the breath of his mouth."* (Psalm 33:6) This "breath" or "word," in Greek, is called *"Logos."* (I capitalized it because the Apostle John told us He was the One through whom all creation was formed.)

Since we are reading Hebrew from right to left, we would think of it as a 4 followed by a 5. These not only add to 9, but when seen together, become 45.

450 = The work of his hands, מעשי ידיו (Psalm 111:7)
45 = Adam, אדם

By the Gematria, we see that the number 45 describes the creation of all things, including Adam. But the individual letters are 4 and 5, which, in the numerics of the Bible, represent "judgment" and "grace." Both of these concepts relate to Adam. He was placed under judgment when given a law. And it should be noted, that judgment is not condemnation – judgment is bringing the evidence to bear and making a decision on the basis of that evidence. The decision may be favorable or unfavorable. In Adam's case, the judgment was unfavorable. And that is where the number 5 makes its entrance. By the "grace" of God, Adam was not simply wiped out. He was given grace which provided the opportunity for redemption.

The Apostle Paul told us *"As in Adam all die, so in Christ shall all be made alive."* To paraphrase his words,

we know that all humans die because of the sin of Adam, and so all will be made alive through the redemptive blood of Christ. It is a promise.

The Great Pyramid, a *delta* shape, sits at the head of the Nile Delta. It is a monument picturing the redemptive work of Jesus Christ. It becomes a "door" which is open to the "breath of God" – the means of restoration of all that Adam lost. But 4 means judgment, and the work of restoration is a time of judgment – not of condemnation, but of bringing the evidence to bear. It is a work of grace, shown by the number 5, through the "breath of God" – the One who made all things and who will restore all things through the merit of His shed blood.

> *When the judgments of the Lord are in the earth, the inhabitants of the world will learn righteousness."* (Isaiah 26:9)

It is surely a work of grace.

> *Give the king thy judgments, O God, and thy righteousness unto the king's son. He shall judge thy people with righteousness, and thy poor with judment. The mountains* (kingdoms) *shall bring peace to the people, and the little hills, by righteousness. He shall judge the poor of the people, he shall save the children of the needy, and shall break in pieces the oppressor. They shall fear thee as long as the sun and moon endure, throughout all generations. He shall come down like rain upon the mown grass: as showers that water the earth. In his days shall the righteous flourish; and abundance of peace so long as*

the moon endureth. He shall have dominion also from sea to sea, and from the river unto the ends of the earth. (Psalm 72:1-8)

The surface text is a beautiful promise. The hidden code confirms it. The concept of judgment in this text bears the number 4.

400 = He shall judge the people with righteousness

This is the work of Jesus Christ. And in Revelation 22:1 John saw a beautiful *"river of life"* flowing from the throne of God. It bears the number value of 1776. If we multiply 1776 by 4, the product will be 7104. It is the Gematria for the statement made by the Apostle Paul, *"When the time had come, God sent forth his Son, born of a woman."* (Galatians 4:4). This number was confirmed by the angel who brought the message to Mary that she would have a son. He said, *"The power of the Most High will overshadow you, and for that reason the holy offspring will be called the Son of God."* (Luke 1:35) It has a Gematria value of 7104.

7104 = When the time had come, God sent forth his Son, born of a woman.
7104 = The power of the Most High will overshadow you, and for that reason the holy offspring will be called the Son of God.

How carefully God has interwoven the numbers to

tell the story of salvation through Jesus Christ. And how beautifully He has illustrated it in the life-giving waters of the Nile.

```
        1776 = River of life
   x       4   Judgment
   _____
        7104   Jesus Christ
```

```
         888 = Jesus
   x       8   New Beginning
   _____
        7104   Jesus Christ
```

"Come, all you who are thirsty, come to the waters..." What a beautiful invitation! Salvation through Jesus Christ is free. *"... come, buy wine and milk without cost."*

While working with the Gematria contained in this invitation, I was thrilled to find that *"come to the waters"* has a number value of 176. Immediately my mind went back to Genesis and the Garden of Eden. That perfect little plot of ground, made especially for the perfect man that God had created, has a Gematria value of 176 (בעדן-ך). Is there a connection? Yes, a magnificent connection!

Adam had been created perfect. He had been given

a perfect home in which to live. And he had direct communion with God in a Father-son relationship. What a wonderful condition! And it is all identified by the number 176.

Now, at the Delta, the invitation is given: *"Come to the waters."* It is an invitation to come to the restoration of all that Adam had lost. It also bears the number 176.

176 = Garden of Eden

176 = Come to the waters

The prophet Habakkuk had described this Delta condition when he wrote, *"For the earth shall be filled with the knowledge of the glory of the Lord...."* It has a Gematria value of 176. But he described it further, to the Great Sea where the waters come to rest – representing eternity: *"... as the waters cover the sea."*

The number 176 was obtained by adding the Hebrew letters in the phrase *"come to the waters."* However, when we multiply those same letters, the number 1728 is produced. It is also the Gematria value of *"Holy Jerusalem."* This is the New Jerusalem which John saw in vision on the Isle of Patmos.

The Delta condition is the Millennium. It is the time of restoring to man all that was lost by Adam. It is the time during which divine government will replace

man's governments – a time when the laws of God will be written in the hearts of all mankind. By the end of the Millennium, divine government – the New Jerusalem (1728) – will be fully established in the earth. God's ways are magnificent!

If the restoration of all that Adam lost is represented by a "delta" condition, it opens the possibility that Adam had been in a "delta" condition when he sinned.

So, just where was the Garden of Eden, anyway? In researching the concept, I became aware of many and varied theories. The scriptural descriptions leave many unanswered questions, thus there has been much speculation and suggestion.

The Genesis story describes Eden as a rather large place – but the "Garden" was in its eastward part. It was the recipient of the waters from four rivers, making the land fertile for the growing of a perfect garden. These four rivers are named in Genesis as Pison, Gihon, Hiddekel (Tigris), and Euphrates. It could not be expected to find these four rivers in their same exact locations today, because the great flood of Noah's day would have undoubtedly re-arranged the terrain and thus the flow of the rivers. However, we do have two of them that are well known – Tigris and Euphrates.

Today, these two rivers flow southward and unite before flowing into the Persian Gulf. A map of the ocean floors reveals that this great river once had a large delta, all of which is now underwater. And, surprisingly, the point where the river began to fan out into its delta was exactly

30° N. latitude, the exact same latitude on which the Nile begins to fan out into its great Delta.

The Nile flows northward, with its Delta flowing north and into the Great Sea, the Mediterranean. The Euphrates flows southward, with what was once its delta flowing south into the Persian Gulf. The apex of both deltas rests on the 30° N latitude line.

Could this delta, which has now been inundated by the sea, have been the site of the Garden of Eden?

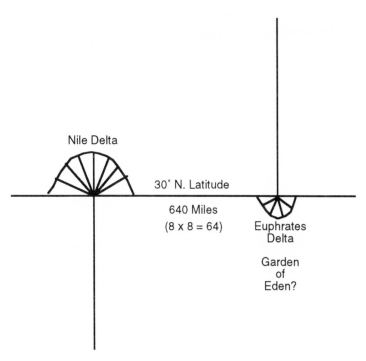

The delta of the Euphrates flowed southward from the 30° line. It is a direction that symbolizes moving away

from God. The delta of the Nile, on the other hand, flows northward from the 30° line – the direction that the Bible indicates is toward God. Could this be telling us something?

When Adam sinned, he began to go in the direction away from God. However, when all of Adam's posterity begin earth's great Millennium, they will flow in the direction that is toward God, having passed through Cairo (meaning victory), representing the victory over death that was purchased for them by Jesus Christ, who, at the age of 30 offered himself as man's redemption price.

This suggests that the 640 miles between the Euphrates delta and the Nile delta may have symbolic meaning. It appears to represent the distance between the fall and the redemption. Zeros can be dropped when working with Gematria, so let's see what the numbers 6 and 4, and 64, represent.

There was a span of 4,000 years between Adam's sin and the payment of the price by Jesus Christ on the cross of Calvary. And there is a span of 6,000 years between the fall and the beginning of restoration.

Truth *(alethea)* has a Gematria value of 64 (8 x 8). Judgment, in Hebrew, has a value of 64, and the Hebrew word meaning "to give rest" has a value of 64.

As I was musing over this possible symbolism, I became aware of the Covenant that God made with Abraham. It included a promise to bless *"all the nations* (families) *of the earth."* He said, *"Unto thy seed have I given this land, from the river of Egypt unto the great*

river, the river Euphrates." (Genesis 15:18)

Why was the scope of the Covenant from the Nile to the Euphrates? Was it because the Euphrates represents the fall of man through Adamic sin, and the Nile represents the restoration of man through Jesus Christ, with two time spans of 6,000 and 4,000 years between?

Perhaps when God made this Covenant with Abraham, He was symbolically including the whole world and all mankind by saying it would reach from the Nile to the Euphrates, healing even that which happened in the Garden of Eden.

This thought is imbedded into the text by its Gematria.

4283 = "To your seed I have given this land from the river of Egypt to the great river, the river Euphrates."

Amazingly, the total numerical equivalent for this verse is 4283, which is the Golden Proportion of 6930. In Jeremiah 3:17 we find a description of the capital city of divine government; it is called *"Jerusalem, the throne of Jehovah."* It has a Gematria value of 693. The numbers suggest the world-wide scope of the blessings of divine government being established in the earth. I suggest the numerical connection is no coincidence. It has the appearance of divine design, for the Golden Proportion is used throughout the word of God to show His divine principle of growth and progress toward a desired goal.

Modern physics has labeled the Golden Proportion as the "Growth Constant." This physical constant is 1:1.618, or it is often shortened to .618. How appropriate that we find Jerusalem itself to be a display of this divine principle, by its Gematria.

618 = The heart of Jerusalem (Isaiah 40:1)

$$6930 \times .618 = 4283$$

6930

4283

Golden Rectangle
of
Abrahamic
Covenant

The sum of the digits for *"Jerusalem, the throne of Jehovah"* is 18 (6 + 9 + 3 = 18). As has been observed in the Gematria of the scriptures, the number 1 represents beginning, and the number 8 represents a new beginning.

The length of the Nile Delta, from its beginning at 30° N. latitude to its farthest reaches northward is 108 miles. Symbolically it flows northward from the beginning of earth's great Millennium to its ultimate end, where

it flows into God's Great Eighth Day, as is represented by the Great Sea.

If we were to trace a compass along the extremities of the Nile Delta, the point of the compass would be resting on the Great Pyramid. The Delta, in its positional relationship to the Great Pyramid, forms a quadrant of a circle, with the Great Pyramid at its center. If we continued drawing the remainder of the circle, it would have a diameter of 216 miles.

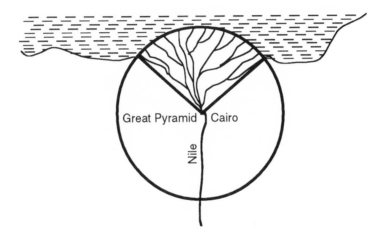

A circle with a diameter of 216 miles is something we see every month of our lives – 2160 miles is the diameter of our moon. The symbol is magnificent.

The 90° angle of the quadrant that forms the Delta has its apex at the Great Pyramid. In fact, we could narrow it down to the topstone of the Pyramid – except it does not have one. Perhaps that statement needs to be

qualified. It would be more correct to say that the topstone was never placed. Jesus said it was "rejected" by the builders. He called it *"The stone which the builders rejected,"* (Matthew 21:42). By adding all the number values for the Greek letters in this statement, we obtain a total of 2160. Amazing! Was He talking about the topstone of the Great Pyramid, the moon, or the Nile Delta?

He was, in fact, talking about Himself. He said this stone that the builders rejected, has become the *"head of the corner."* The head of the corner can be none other than the topstone. Yet, the symbol can be full blown to include all three.

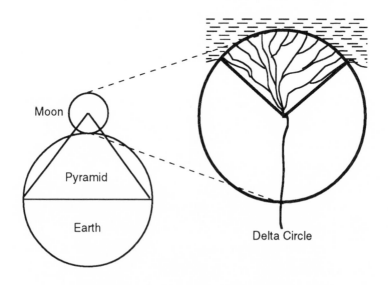

Moon

Pyramid

Earth

Delta Circle

2160 Miles – Diameter of moon
216 Miles – Diameter of Delta circle.

2160 = The stone which the builders rejected
2160 = Kingdom of the Father (Matt. 13:43)
216 = All nations shall serve him (Psalm 72:11)

In the above diagram, the moon is placed tangent to earth. When this is done, using their exact dimensions, the triangle that can be drawn within their centers is precisely the proportions of the Great Pyramid. It suggests that the Great Pyramid was patterned by the size of earth and its moon.

Moonlight is the reflected light of the sun. The sun is a representation of God, the source of light and life. Thus the moon appropriately symbolizes God's law that was originally given to Moses. The principles of God's divine law were encorporated into the Ten Commandments. It was a small representation of divine law – a reflection of God Himself.

The "moonlight" went out on the afternoon when Jesus hung upon the cross. In fact, the literal moon went into eclipse as a sign that the symbolic moonlight – the Law Covenant – had been put to an end.

That law had been given to Moses on Mount Sinai, which is also called Horeb. It is not to be overlooked that the name Horeb has a Gematria value of 216. The transaction on Mount Horeb that day was symbolized by the moon, whose diameter is 2160 miles.

But when Jesus figuratively "nailed the law to his cross" it does not mean the end of that law. It was the end of that Marriage Covenant between God and Israel. The

law given on Horeb was indeed a marriage covenant.

But the writer of the book of Hebrews makes it very clear that a New Covenant was inaugurated when the Old Covenant was ended. He wrote, *"He taketh away the first, that he may establish the second,"* (Hebrews 10:9).

The *"first"* was established by the blood of bulls and goats; the *"second"* was established by the blood of Jesus Christ. It is an everlasting covenant through which all who died in Adam will be able to come back into a "sonship" relationship with God.

The full establishing of this covenant in the earth will be accomplished by the end of earth's great Millennium, pictured by the Nile Delta. The Delta circle has a diameter of 216 miles. By the time the waters reach the Mediterranean, divine law will have been fully written into the hearts of men. The New Jerusalem, which is the embodiment of divine law, will have been fully established.

The relationship of the New Jerusalem to divine law is magnificently shown by Gematria. It is so awesome that our finite human minds have trouble grasping its fullness. It is the work of an awesome God.

John described the New Jerusalem which he saw in vision. It's shape was that of a cube, with twelve gates (three on each side), on which the names of the twelve tribes of Israel were inscribed. It also had twelve foundation stones – gemstones – on which were inscribed the names of the twelve apostles. The Gematria for these names is spectacular.

Judah	Ιουδα	485
Reuben	Ρουβην	630
Gad	Γαδ	8
Asher	Ασηρ	309
Nepthalim	Νεφθαλειμ	650
Manassas	Μανασσης	700
Simeon	Συμεων	1495
Levi	Λευι	445
Issachar	Ισσαχαρ	1112
Zebulon	Ζαβουλων	1360
Joseph	Ιωσηφ	1518
Benjamin	Βενιαμιν	168
		8880

8880 x 12,000 from each tribe = 10656 (dropping zeros)

Peter	Πετρος	755
Andrew	Ανδρεας	361
James	Ιακωβος	1103
John	Ιωαννης	1119
Phillip	Φιλιππος	980
Nathanael	Ναθαναηλ	150
Levi (Matthew)	Λευι	445
Thomas	Θωμας	1050
James (son of Alpheus)	Ιακωβος Αλφαιου	2115
Lebbaeus (Thaddeus)	Λεββαιος	320
Simon the Canaanite	Σιμων ο Καναναιος	1573
Judas	Ιουδας	685
		10656

10656 + 10656 = 21312

The Ten Commandments

1, You shall have no other god before me.

לא־יהיה־לך אלה אחרן על־פני

140 100 259 36 50 30 31 ..646

2. You shall not make for yourself an idol in the form of anything in heaven above or on the earth beneath or in the waters below. You shall not bow down to them or worship them.

לא תעשה־לך פסל וכל־תמונה אשר בשמים ממעל ואשר בארץ

293 507 180 392 501 501 56 170 50 775 31

מתחת ואשר במים מתחת לארץ לא־תשתחוה להם ולא תעבדם

516 37 75 1119 31 321 848 92 507 8487850

3. You shall not misuse the name of the LORD your God.

לא תשא את־שם־יהוה אלהיך לשוא

337 66 26 340 401 701 31.......................................1902

4. Remember the Sabbath day by keeping it holy.

זכור את־יום שבת לקדשו

440 702 56 401 233..1832

5. Honour your father and your mother.

כבד את־אביך ואת־אמך

61 407 33 401 26 ...928

6. You shall not murder.

לא תרצח

698 31 ...729

7. You shall not commit adultery.

לא תנאף

531 31 ...562

8. You shall not steal.

לא תגנב

455 31 ...486

9. You shall not give false testimony against your neighbor.

לא־תענה ברעך עד שקר

600 74 292 525 31 ...1522

10. You shall not covet your neighbour's house. You shall not covet your neighbour's wife, or his manservant or maidservant, his ox or donkey, or anything that belongs to your neighbor.

לא תחמר בית רעך לא־תחמר אשת רעך ועבדו ואמתו

453 88 290 701 452 31 290 412 452 31

ושורו וחמרו וכל אשר לרעך

320 501 56 260 518 ...4855

21312

(See End Notes 1)

The total Gematria for the Ten Commandments is 21312. It is a palindrome – that is, it can be read forward or backward.

The names inscribed on the gates bear the number 10656; and the names inscribed on the foundation stones bear the number 10656. Thus the New Jerusalem is identified by their total, which is 21312.

The digits are the first three numbers of creation: 1 representing God; 2 representing the Logos, who was the One through which all creation came into being; and 3 which is the first number with form, thus representing the material creation. The sum of the digits is 9, which is the number used throughout the Gematria of the scriptures to represent fullness, completion, perfection, fulfillment and finality.

The full accomplishing of the divine purpose for mankind, in establishing the New Jerusalem in the earth, is the work of Jesus Christ. It is not surprising, then, to realize that 9 times Jesus Christ (2368) is 21312.

2368 = Jesus Christ
Ιησους Χριστος

9 x 2368 = 21312

Multiplication of the digits produces an equally magnificent result.

$$2 \times 1 \times 3 \times 1 \times 2 = 12$$

Twelve is the number which is basic to the New Jerusalem – it having 12 gates and 12 foundation stones, and a wall of 144 (12 x 12). And, if we multiply the sum of the digits by the multiplication of the digits, we get the wonderful number 108.

$$2 + 1 + 3 + 1 + 2 = 9$$
$$2 \times 1 \times 3 \times 1 \times 2 = 12$$

$$9 \times 12 = 108$$

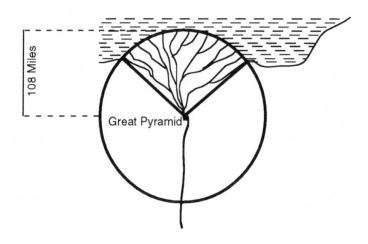

108 Miles

Great Pyramid

The Delta, as it fans out from its central point at the Great Pyramid, reaches a maximum of 108 miles where it peacefully flows into the Great Sea. It represents the time when divine law will be written in the hearts of men. It is a process, from a small beginning to its magnificent conclusion. The Hebrew word that is sometimes translated *"law"* and sometimes *"commandment"* is חק, which has a Gematria value of 108.

```
108 = Law  (Commandment), חק
```

The picture formed by the Delta is of many streams branching out from one main source, bringing rich nutrients to the land – and, indeed, forming the land. It beautifully illustrates the work of the Kingdom of Jesus Christ, as it spreads out through all the earth, bringing its life-giving waters for the healing of the nations.

Ezekiel saw a similar picture in vision. However, he did not see the river branching out into many streams: he saw one stream, coming out from Jerusalem, getting deeper and deeper as it flowed down toward the Dead Sea, and eventually healing the waters, making it a live sea. The analogy is the same.

After describing this river, Ezekiel wrote, *"And everything shall live whither the river cometh,"* (Ezekiel 47:9). As is well-known, the Hebrew sentence structure

is different from our English way of speaking. Thus to obtain the correct Gematria, we must follow the Hebrew text and its grammar. It reads, *"... so will live everything where the river flows."* This all-inclusive statement defines what will be healed by the river – it is *"everything."*

The phrase *"everything where the river flows"* has a Gematria value of 1008. It includes the entire earth, along with its moon (which represented the Law Covenant until it was "nailed to the cross"). During the Millennium the new Law Covenant will be written in the hearts of men – still symbolized by the light of the moon.

The number 1008 is a beautiful symbol of all God's works in relation to man, bringing their ultimate restoration and reconciliation to Him.

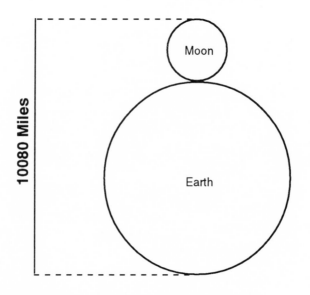

1008 = Everything where the river flows (Ezekiel 47:9)

1008 = The work of thy fingers (Psalm 8:3)

1008 = The Lord of hosts shall reign in Mount Zion (Isaiah 24:23)

1008 = The Lord is high above the nations, and His glory above the heavens (Psalm 113:4)

When the angel told Mary that she would bear a son, he said *"He shall be great, and shall be called the Son of the Highest, and the Lord God shall give Him the throne of David."* (Luke 1:32) It has a Gematria value of 10080, encompassing the fullness of the earth and its moon, whose combined diameters are 10080 miles.

As Ezekiel viewed with wonder the vision of the river, flowing out from Jerusalem, he saw them widen and deepen as they flowed down toward the Dead Sea, healing its barren waters. His mind must have envisioned the Garden of Eden, with its rivers that brought abundance of life. To Ezekiel, the vision was as a restoration of man's lost Eden home. He saw once again the river that watered the garden, and the trees of life in the midst of the garden that had been lost to mankind for so many weary centuries. He saw them now restored before his wondering eyes.

Perhaps Ezekiel remembered the promise that God had given to Moses of His abundant outpouring of blessings upon them if they would only obey Him. It was not an empty promise. It was a promise that He desired to

lavish upon them. It was a promise that will indeed be kept.

> *If ye walk in my statutes, and keep my commandments, and do them, then I will give you rain in due season, and the land shall yield her increase, and the trees of the field shall yield their fruit. And your threshing shall reach unto the vintage, and the vintage shall reach unto the sowing time, and ye shall eat your bread to the full, and dwell in your land safely. And I will give peace in the land, and ye shall lie down, and none shall make you afraid."* (Leviticus 26:3-6)

This promise will be kept abundantly when mankind obeys fully and from the heart, the divine laws of God. By the end of the Millennium, this will be the condition of God's human family, whom He loves. His blessings of life will be lavished upon them. It is pictured by the waters of the Delta, as they flow peacefully into the Great Sea.

Isaiah painted for us a word picture of this coming time of God's blessing upon obedient mankind.

> *"The work of righteousness shall be peace; and the effect of righteousness quietness and assurance forever. And my people shall dwell in a peaceable habitation, and in sure dwellings, and in quiet resting places."* (Isaiah 32:17-18)

But no rain falls on the Delta! Is this not a contradiction of the picture? No. It is a beautiful confirmation of it.

All the life and abundance that is produced by the most fertile land on the face of the earth – the Delta – is brought there by the river. It does not come from above as rain.

From Khartoum northward to the tip of the Delta no rain occurs. It is barren desert, except for the life and nutrients obtained from the river.

Abundant rain falls upon Lake Victoria, as well as the Ethiopian highlands where Lake Tana receives it in abundance. It is from above, and provides the life source for the river. The rain from above pictures the direct blessing from God, bringing life. It is received by Lake Victoria and Lake Tana, and pours forth as a river of life through Jesus Christ. The means whereby man can receive life is only through Jesus Christ.

Man's direct communion with God ended when Adam sinned. Now we can only approach God through the blood of Jesus Christ. This will also be true during the Millennium, pictured by the Delta. Only upon the Great Sea does rain fall once again. And it is only at the end of the great Millennium that man will once again enjoy the direct communion with God which Adam had before he sinned. This is part of the "all" that will be restored to Adam's family.

"Then cometh the end, when he shall have delivered up the kingdom to God, even the Father; when he shall have put down all rule and all authority and power. For he must reign, till he hath put all enemies under his feet. The last enemy that shall be destroyed is death...

And when all things shall be subdued unto him, then shall the Son also himself be subject unto him that put all things under him, that God may be all in all." (I Corinthians 15:24-28)

In Revelation 22 we find beautiful symbolic pictures of the Millennium, particularly at its ending days. It paints for us the scene of Jesus and His bride, giving the final invitation – even those of mankind who have already heard and obeyed join in sounding the invitation to "Come."

"And the Spirit and the bride say, Come. And let him that heareth say, Come. And let him that is athirst come. And whosoever will, let him take the water of life freely (without cost)." (Revelation 22:17)

"In the last day, that great day of the feast, Jesus stood and cried, saying, If any man thirst, let him come unto me, and drink." (John 7:37)

Jesus made this statement on the last day of the Feast of Tabernacles. Earth's great Millennium is pictured by the Feast of Tabernacles. It was also called the *"Feast of Ingathering,"* – a fitting symbol of the ingathering of all mankind into the Kingdom and into the abundance of life it has to offer.

The *"last day"* would be at the end of the seven days, just before the "day of conclusion," the *Atzereth*. The end of the great antitypical Feast of Tabernacles will be 3,000 years from the time when Jesus hung on the cross and paid the price for the sin of Adam. Not surprisingly, the Gematria value for *"If anyone thirsts, let him come,"* is

3000. There are no coincidences in the works of God – only gems of planned beauty.

Three thousand years from the "day that changed the world" when Jesus hung on the cross brings us to the end of earth's great Millennium. It brings the river to the Great Sea, where its healing, life-giving waters find rest.

And, it is amazing to find that the river miles from Lake Tana – the heart of God – to the Great Sea measure 3,000. The heart of God overflowed for His human family by giving Jesus Christ to restore to us all that Adam had lost.

> *"For God so loved the world, that he gave his only begotten Son, that whosoever believeth in him should not perish, but have everlasting life."*
> (John 3:16)

The number 3 was the basic number in the process of creation – it being the first number with form. And it is the last number in the process of restoration. We observed the first three numbers, 1, 2, 3, in the beautiful palindrome of divine law – 21312. This number described the New Jerusalem which will be fully established in the earth by

the end of the great Third Day. The numbers are meaningful, they are beautiful, and they are exciting!

In the above timeline, we observe that the great 3rd day is the same as the great 7th day. They both describe the Millennium. Three and seven are the theme that is carried all the way through from creation to complete restoration. Genesis 1:1 has a Gematria value of 37 x 73. The number 37 is the Gematria for "heart." It was out of the heart of God (heart-shaped Lake Tana) that the life-giving waters (Jesus Christ) flow 3,000 miles for the complete restoration of God's human family. The Gematria for the Hebrew word שׁלם, meaning "to restore" is 370.

Divide 21312 by 37 and we find the number for "life."

21312 ÷ 37 = 576

576 = Life (pneuma, πνευμα)

The Nile, the river of life, comes from the highlands, and flows down into the Great Rift Valley, to heal all who have fallen into the chasm – the great rift between God and man. But attempts have been made, by man to get power from the river and to harness its wealth. Great dams have been built. In the next chapter we will take a look at the process of damming the river.

10

Damming the River

Here at last I stood on the brink of the Nile; most beautiful was the scene, nothing could surpass it! It was the very perfection of the kind of effect aimed at in a highly developed park: with a magnificent stream, 600 to 700 yards wide, dotted with islets and rocks....

John Hanning Speke wrote with exuberant joy in his journal. Upon seeing the Nile, as it plunged over the escarpment and down into the Great Rift, he felt a sense of divine awe, and suggested that his men should shave their heads and "bathe in the holy river, the cradle of Moses."

He wrote, "It was a sight that attracted one for hours – the roar of the waters, the thousands of passenger-fish leaping at the falls with all their might; the Wasoga and Waganda fishermen coming out in boats and taking post on all the rocks with rod and hook, hippopotami and crocodiles lying sleepily on the water...."

Speke named the place Ripon Falls, after the gentleman who once presided over the Royal Geographical Society. But to Speke, it was the most beautiful spot on the face of the earth. It was the fulfillment of all he had

hoped and struggled for. He wanted to shout it to all the world.

Today, this "most beautiful spot on the face of the earth" is submerged in the waters behind Owens Falls Dam.

When I first realized this, I was sadly reminded of an excursion my husband and I took with our two small children into the "wilds" of Canada. We had seen on the map a series of waterfalls in Ontario and Manitoba, and we decided to share with our children these wonderful works of nature. To our surprise and great disappointment, each waterfall had been submerged by the waters behind a hydroelectric dam. Men had harnessed the power in the river, and in so doing, destroyed the beauty of nature's wonder.

Power was gained at the expense of beauty. Many consider this a fair trade.

At the north end of Lake Victoria its only outflow plunges over the rocky cliff down into the Great Rift, creating magnificent turbulence as it continues to fall deep into the valley. Speke stood in reverence as he beheld this most beautiful scene he had ever witnessed.

The Great Rift Valley, into which the waters of life plunge, is a fitting symbol of the great rift that occurred between God and man when Adam sinned. Prior to this, Adam had sonship and communion with God. But now he was cast out, and driven from the beautiful garden that had been made for him.

But wonder of all wonders, a ransom would be pro-

vided for him. A promise of hope was given. God said to the serpent who had deceived them,

> *I will put enmity between thee and the woman, and between thy seed and her seed; it shall bruise thy head, and thou shalt bruise his heel.*
> (Genesis 3:15)

The *"seed of the woman"* would be none other than the Lord Jesus Christ. And so the life giving waters from Lake Victoria plunged down into the rift after them.

John Hanning Speke, in the Living Parable, would represent those prophets who told of the coming Deliverer. The last of those prophets was John the Baptist. When he made the announcement that Jesus was coming, it cost him his head.

For six millennia the great deceiver has been at work building the dam that submerges the falls. He began by telling Adam and Eve *"Ye shalt not surely die."* And men have believed him, by promoting their doctrines of immortality that completely negate God's statement to Adam, *"In the day that thou eatest thereof, thou shalt surely die."*

Owens Falls Dam was built to take the power from the water and turn it into hydroelectric power for their own use. In so doing, they destroyed the falls. The great deceiver has taken the power from the blood of Jesus and used it for personal gain, both for himself and for his followers. He said,

> *"I will ascend into heaven, I will exalt my throne above the stars of God: I will sit also*

upon the mount of the congregation in the sides
of the north. I will ascend above the heights of
the clouds; I will be like the Most High." (Isaiah
14:13-14)

His followers have gained power from the water by building for themselves great empires in the name of Jesus. One called the Holy Roman Empire is a good example, and there are many others. Even in countries who boast the separation of church from state, the powerful religious leaders wield great influence in the politics of rulership. Power is money and money is power, and the magnificent beauty of the falls becomes submerged under the greed of men, led by the greed of the great deceiver.

But the dam does not stop the river, it only impedes its force in a measure. The dam which submerges Ripon Falls does not prevent the life-giving qualities of the water from depositing their wealth downstream. Most of those nutrients are supplied by the Blue Nile which makes its entrance into the White Nile at Khartoum.

Many dams have been built to harness the flow of the Nile. These were for the purpose of flood control and to save the water for times most beneficial to their crops . Those dams built downstream from Khartoum did not prevent the rich silt from depositing its life-giving abundance into the farm land, because they were low dams, allowing the Nile flood to overflow them.

But during the years 1960 to 1965 a high dam was under construction at Aswan.

The city of Aswan was the most southerly outpost

of the Roman Empire. It was the great caravan center of its day. The name Aswan means "market," and it truly was the market-place of Africa. The wealth of Africa was made available to the rest of the world through Aswan.

The name Aswan comes from the red granite, called "sianite" which is quarried there. This was the source of all the red granite used in the Great Pyramid. In the symbolism of the Great Pyramid, red granite represents that which is in God's realm of righteousness.

Aswan was the location of the "first cataract" on the Nile. It, in reality, is not the "first" cataract, it is the last one as the river flows. It was named the "first" because early explorers, attempting to find the source of the Nile, would travel upstream from Cairo. This first cataract they encountered would become a barrier they could not cross. The swiftness of the flow through the narrow gorge was impossible for early explorers to navigate; and the walls of the gorge too steep to portage.

And so the "last" became the "first." As I read this history of the explorations of the Nile, the statement of Jesus kept invading my mind. He said *"I am the Alpha and Omega, the Beginning and the End, the First and the Last."* (Revelation 22:13) But what has Jesus to do with Aswan?

The name means "market." Spelled in Hebrew it is מערב which has a Gematria value of 312. These first three digits have wonderful meaning in the study of the number symbolisms. They are, in fact, the first three digits, 1, 2 and 3. These digits are unique to all the rest of

the digits, because they create both the sum and the product six.

$$3 \times 1 \times 2 = 6$$

$$3 + 1 + 2 = 6$$

As has been shown, six is the number that pertains to the earth and man. And because Jesus came as the second Adam, a perfect man, he also bears the number 6.

But the free gift of life that Jesus purchased for man bears the number 312.

Gift

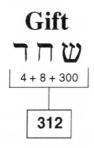

שׁ ח ד

| 4 + 8 + 300 |

312

"Therefore as by the offence of one (Adam) *judgment came upon all men to condemnation; even so by the righteousness of one* (Jesus) *the free gift came upon all men to justification of life."* (Romans 5:18)

Aswan represents the full measure of that *"free gift"* (312) which is available in the marketplace (312).

"Ho, everyone that thirsteth, come ye to the waters, and he that hath no money; come ye, buy, and eat; yea, come, buy wine and milk without money and without price." (Isaiah 55:21)

The number of river miles between Aswan and the Great Pyramid is 666. These are peaceful miles. As the turbulent waters of the Nile flow through the narrow gorge they come to rest in the peaceful river that flows northward, until it reaches the Great Pyramid, where it spreads its fingers into the green fan of the Delta.

At the end of this 666 miles of peaceful flow of the river, the Great Pyramid rises its 485 feet to the sky. Today it is not actually that high because it has no topstone. That missing topstone would raise its height 364.25 inches above its present height (actually, in units known as Pyramid Inches which is nearly identical to our British Inch).

That missing topstone was mentioned by David when he wrote *"The stone which the builders refused is become the head of the corner."* (Psalm 118:22) The Hebrew words לראש פנה, *head of the corner,* have a Gematria value of 666. It pictures Jesus Christ. He bears the number 6 because he came as a perfect man to assume the death penalty for Adam. Thus the river miles between Aswan and the Delta display the number 6 at both ends. Aswan represents the fullness of the life-giving sacrifice of Jesus Christ, bringing life in its fullness to man and restoration to the earth.

This is also shown by its location on the face of the planet. Aswan is positioned at 24° N. latitude, and 33° E.

longitude. They are not random numbers. It appears to be part of a magnificent plan.

These two numbers are factors of 792. And, as has been noted, 792 is the Gematria for *"salvation"* as it is spelled in Hebrew.

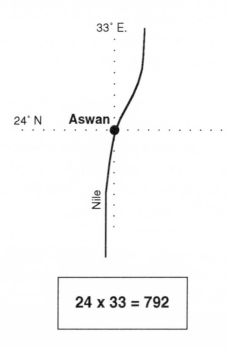

792 = Lord Jesus Christ, אלהא יהושע משיח

792 = Salvation, ישׁעות

792 = This is what the Lord says, I will extend peace to her like a river. (Isaiah 66:12)

792 = They thirsted not in the desert, (Isaiah 48:21)

7920 miles – Mean diameter of the earth

This is the position of Aswan on our planet. It pictures the place of full salvation through Jesus Christ. It is the marketplace where we buy life without price – it is free.

But something happened to the waters of Aswan. The natural cataract has now been submerged by the 364 foot Aswan High Dam.

How high is it? Did they really build it 364 feet high? The number shouts to the heavens. It says "counterfeit," "fraud," "cover-up."

Why?

Let's take a look at this amazing number, 364. In Psalm 2:2 Jesus is called the *"Anointed One,"* משיחו. It has a Gematria value of 364. But there is a usurper who takes the same number. It is Satan, השטן whose number is also 364. The usurper tries to take the place of the One whose right it is. He sets himself up as a liberator and a provider for the people by means of a dam, 364 feet high, which virtually obliterates the flow of life-giving water from the Anointed One.

Before the construction of the dam, Egypt's President Nasser proposed that it would provide energy for industrializing this poor nation, and provide water for a vast empty desert, to feed Egypt's hungry people. However, the result of the dam has proven to be the decline in the quality of agriculture through the loss of the rich nutrients that are now trapped behind the 364 foot wall that is holding back the river.

Low-cost electrical power has increased industrial

development along the river, however, as should have been expected, wastes from these industries has ended up back in the river, reducing its life-giving effect upon the land. Moreover, the lack of nutrients reaching the vast agricultural lands below the dam have caused the necessity of using manufactured herbicides, pesticides, and chemical fertilizers. The net result has become further contamination of the river.

The building of the Aswan High Dam has held back the natural flow of the river, forming the vast Lake Nasser. In a desert land that receives no rain, temperatures reach as high as 135 degrees in summertime. This causes the lake to lose 350 billion cubic feet of water annually through evaporation. The result is that the water has become more saline, reducing its life-giving benefit to agriculture. In fact, in many places fields have been encrusted with salt.

Although much of this salting of the land is a natural process, yet it now lacks the annual flooding of the land which flushed and leached out the salts. The natural process of cleansing and replenishment has been destroyed.

This disruption of the natural process has resulted in fewer marketable crops. By ten years, this had caused productivity to be reduced by 50 percent on 1.2 million acres below the dam.

Silt-free water was now flowing faster below the dam, endangering the foundations of bridges and scouring the riverbed, and tearing away the banks. To remedy the new problem, a proposal was made to build ten

barrier dams between Aswan and the Delta.

For centuries men have built smaller dams along the Nile; but these dams created much smaller reservoirs which emptied each year in the dry season. This allowed the silt to reach the huge farmlands downstream, maintaining nature's balance.

The Aswan High Dam, however, is one of modern man's construction wonders. It rises 364 feet between the rock walls of the river's bank. It can generate 10 billion kilowatts of power a year, and creates a lake approximately 2,000 square miles.

The Nile valley has an average width of seven miles. Today, 96 percent of Egypt's inhabitants crowd into the narrow Nile valley and its fertile Delta. Erosion of this narrow valley has been the unfortunate result of the Aswan High Dam.

The effects of holding back the water is taking its toll on the fertile Delta. It has lowered the water level in the Delta, allowing salty water from the Mediterranean to back up into the marshes, eroding its fertile soil. Many of the great sand banks which held back the Great Sea have been washed away by the encroachment of the sea, permitting still further invasion of its salty waters. It's waves are now washing away those ancient sand barriers.

Perhaps the analogy could be made that Satan's attempts to thwart God's plan of redemption and restoration, has undermined the promises of the restoration of man, and it has replaced them with God-dishonoring doctrines, which do not provide life, but all of which lead

to death.

Satan's original lie to Adam and Eve was *"Ye shall not surely die."* Yes, it was a lie, because God had told Adam that he would die if he disobeyed. From the Owens Falls Dam, which submerges Ripon Falls, all the way to Aswan, where the life-giving effect of the river has been dammed up and held back, it reveals Satan's attempt to twist and transform the Word of God, and thereby hide from man the glorious plan that God had from the beginning, to *"bless all the families of the earth,"* through the redemptive work of Jesus Christ.

But there's hope! The Great Pyramid will yet have a topstone 364 1/4 feet high. It will literally be man's Pi in the sky. David wrote, *"The stone which the builders refused is become the head of the corner."* He stated it past tense, as if it had already been placed. But what has this yet-unseen topstone to do with the problem of the 364 foot Aswan High Dam? It has everything to do with it. Let's take a look at The Great Pyramid.

11

The Great Pyramid

Once covered with polished white limestone, the Great Pyramid glistened like a jewel in the desert. It was, and still is, one of the seven wonders of the ancient world – and the only one remaining today. Its slightly concave sides permitted it to capture and reflect the rays of the desert sun, causing its brightness to be visible for many miles. In fact, it was once called "The Pyramid of Light," and sometimes just "The Light."

Even today, without its brilliant polished white casing stones, its very mass causes us to stand in awe as we gaze upward at this marvelous structure. Its square base covers thirteen acres. The stone masonry, which was so carefully and skillfully placed into the shape of a pyramid, is enough to build a sidewalk three inches thick, and two feet wide, which would reach around the world.

But this massive edifice is more than just a pile of rock. It is a monument to the redemptive work of Jesus Christ, and the reconciling of all mankind back into sonship with God – all that Adam lost. It is indeed a monument to reconciliation.

There is no record that its topstone was ever lifted into place. The stone itself would have been massive –

more than 30 feet high and about 48 feet wide. Some even suggest it may have been covered with gold. The numbers themselves are impressive, for 30 x 48 = 1440, and as we have seen, the number 144 always represents that which is in God's realm of righteousness.

Some have asked, "If the Great Pyramid tells of the redemption and restoration of man, why is it not mentioned in the Bible?" The fact is, it is indeed mentioned in the Bible, and revealed by Gematria.

The prophet Isaiah wrote:

"In that day there shall be an altar to the Lord in the midst of the land of Egypt, and a pillar at the border thereof to the Lord. And it shall be for a sign and for a witness unto the Lord of hosts in the land of Egypt." (Isaiah 19:19)

This entire verse has a Gematria value of 5449. It is no random coincidence that the height of the Great Pyramid, up to its present summit platform, is 5449 Pyramid Inches. It was the plan of the Architect. Divide this figure by the Egyptian royal cubit, and we get the number 3168, which is the Gematria value for Lord Jesus Christ.

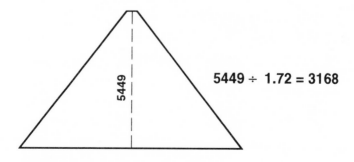

5449 ÷ 1.72 = 3168

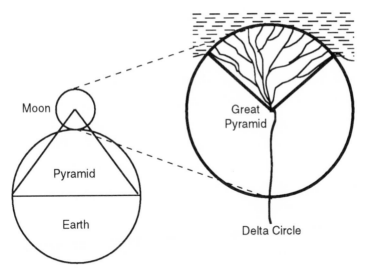

The precise proportions of the Great Pyramid can be drawn on the centers of earth and its moon. And a circle superscribed around the earth, passing through the center of the moon, will have a circumference of 31,680 miles (using sacred geometry's 22/7 for Pi). The Great Pyramid, earth and moon are intricately tied together by the Gematria for Lord Jesus Christ.

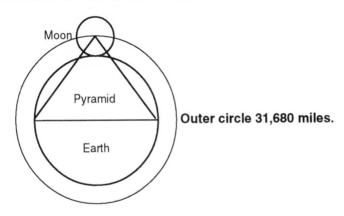

Outer circle 31,680 miles.

The Great Pyramid – a delta-shaped structure – sits at the head of the Nile Delta, 4,000 river miles and a descent of 4,000 feet from Lake Victoria. May I suggest it represents the 4,000 years from the sin of Adam to the birth of Jesus. At the end of those 4,000 years, the Great Pyramid stands as a monument to the redemptive work of Jesus Christ. It is, in fact, a monument to Pi – the means of reconciling a circle and a square. And the work of redemption is for the purpose of reconciling man back into sonship with God.

When the topstone is indeed raised into place, the entire structure will have a height of 5813 Pyramid Inches. This vertical height, is in relationship to its square base exactly as the radius of a circle is to its circumference. It is a Pi ratio. Let's invert a mirror image of this relationship beneath it, and we have a circle containing the Great Pyramid and its mirror image – a diameter of 11,626.

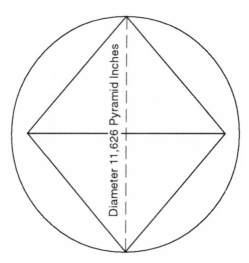

Diameter 11,626 Pyramid Inches

Using Pi times the diameter, we obtain a circle with a circumference of 36524.2 Pyramid Inches. It is the number of days in the mean solar year times 100. Or, we can simply move the decimal point.

Solar time is apparent time. It is uniquely a relationship of the sun to our earth. However, the interval between two successive passages of the vernal equinox over the meridian is slightly less. This is called sidereal time. Sidereal time is real time. The difference between the two is 24 hours per solar year.

> **365.24 is Mean Solar Time**
> **364.24 is Sidereal Time**

We could say that sidereal time is the reconciling of apparent time with the actual relationship of earth to sun. It is the number that represents reconciliation.

In keeping with the known measurements of the Great Pyramid, it was discovered that the topstone would have to be 364.24 Pyramid Inches in height. The topstone represents Jesus – the One who has provided the means by which man can be reconciled to God.

Aswan represents Jesus, the One who makes reconciliation between God and men. We might say it is the promise of reconciliation. But the dam that has been built there is 364 feet high. It represents the attempt of Satan to prevent the ultimate reconciliation between God and men.

The difference between one year of mean solar time

and sidereal time is one solar day. It was interesting to find this day represented by the topstone of the Great Pyramid.

There are 203 courses of masonry from the base to the Pyramid's summit platform. The next course of masonry would be the topstone – 204th. The number is indeed significant.

204 = A day, $\eta\mu\varepsilon\rho\alpha\nu$
204 = The Son of Man, $\upsilon\iota o\nu \ \alpha\nu\theta\rho\omega\pi o\upsilon$

Another mention of the Great Pyramid in the Bible is found in the 4th chapter of Zechariah.

> *"What are you, O great mountain? Before Zerubbabel you will become a plain; and he will bring forth the topstone with shouts of 'Grace, grace to it!'" ... but these seven will be glad when they see the plummet stone (select stone) in the hand of Zerubbabel..."* (Zechariah 4:7-10, NASB).

The *"great mountain"* that will become a *"plain"* is the powerful and imposing governments of man. And Zerubbabel is a picture of Jesus, earth's rightful King on David's throne. When man's right of rulership expires, those kingdoms will be overthrown by the One whose right it is. This concept and symbology was also used by the prophet Micah when he wrote:

> *"In the last days it shall come to pass, that the mountain of the house of the Lord* (Christ's

Kingdom) *shall be established in the top of the mountains* (above man's governments),.. *and people shall flow unto it.... And he shall judge among many people, and rebuke strong nations afar off; and they shall beat their swords into plowshares, and their spears into prunning-hooks: nation shall not lift up a sword against nation, neither shall they learn war any more."* (Micah 4:1-4)

The *"great mountain"* of man's governments will be overthrown by the Kingdom of Jesus Christ. This is when the symbolic *"topstone"* (Jesus Christ), the *"select stone"* will take its promised place.

The topstone of the Great Pyramid will have a base measure of 576 Pyramid Inches wide. It is a number that is used in the Gematria of the Bible to represent the time when Jesus takes his power and reigns as King on David's throne – the time when He brings to an end the mis-rule of man's governments and sets up His Kingdom in the earth.

576 = Messiah the Prince, מ‎שׁיח נגיד (Daniel 9:25 by multiplication)

576 = The Kingdom, מלכות (Daniel 7:27 by multiplication)

576 = I have set my King, נסכתי מלכי (Psalm 2:6 by multiplication)

The delta-shaped Pyramid is positioned at the start of the Delta. The letter *"delta"* in the Greek alphabet has

a Gematria value of 4. Jesus Christ, represented by the topstone is at the center of the Delta Circle. The number 4 represents judgment – not condemnation, but bringing the evidence to bear and executing righteous judgment, which leads to life. The prophet Isaiah wrote:

> *"When the judgments of the Lord are in the earth, the inhabitants of the world will learn righteousness."* (Isaiah 26:9)

A right angle is often used as a metaphor for the restoration of man's sonship relationship to God. It is the alignment of light from the sun with the horizon of the earth. The sun, representing God, sends its light to the earth, bringing life and warmth.

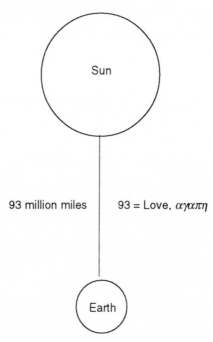

Sun

93 million miles 93 = Love, $\alpha\gamma\alpha\pi\eta$

Earth

The alignment of light with the earth is nature's primary right angle. It symbolizes man's ultimate standing before God in righteousness. This will be the condition of all mankind by the end of earth's great Millennium, when full reconciliation with God is accomplished.

The work of reconciliation began at Calvary, when Jesus presented his perfect human life in payment for the debt of Adam. Converting the 93 million miles into inches, and dividing by the speed of light, produces the number 3168. It is the Gematria for Lord Jesus Christ, as it is spelled in the Greek text of the New Testament. It was through the love (93) of the Father that He sent His Son to redeem Adam and all of Adam's family. The right angle produced by this beam of love, "squares" man with God.

"God so loved the world that He gave his only begotten Son." (John 3:16)

Earth

The angle of the topstone of the Great Pyramid tells the story of this restoration to sonship.

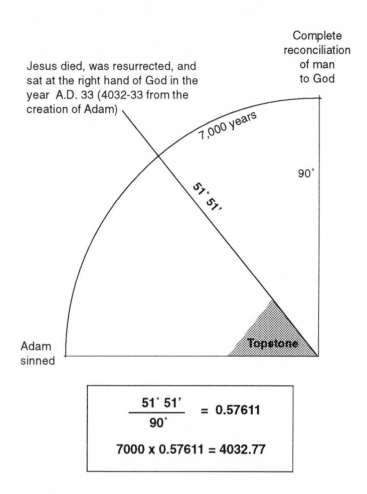

Complete reconciliation of man to God

Jesus died, was resurrected, and sat at the right hand of God in the year A.D. 33 (4032-33 from the creation of Adam)

7,000 years

51° 51'

90°

Adam sinned

Topstone

$$\frac{51° \ 51'}{90°} = 0.57611$$

$$7000 \times 0.57611 = 4032.77$$

By the end of earth's great Millennium, all of Adam's family will have been brought back into full reconciliation with God. Jesus, represented by the Topstone of the Pyramid, provided the means whereby this could be accomplished, when he died and rose again, paying the price for Adam, in the year A.D. 33 (4032-33 years from the creation of Adam).

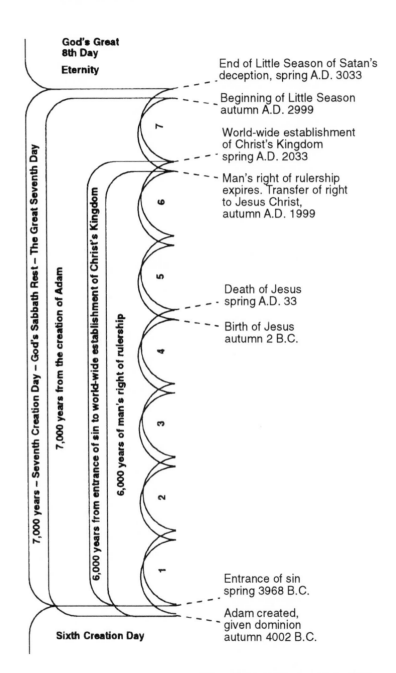

God's Great
8th Day

Eternity

End of Little Season of Satan's
deception, spring A.D. 3033

Beginning of Little Season
autumn A.D. 2999

World-wide establishment
of Christ's Kingdom
spring A.D. 2033

Man's right of rulership
expires. Transfer of right
to Jesus Christ,
autumn A.D. 1999

Death of Jesus
spring A.D. 33

Birth of Jesus
autumn 2 B.C.

Entrance of sin
spring 3968 B.C.

Adam created,
given dominion
autumn 4002 B.C.

7,000 years – Seventh Creation Day – God's Sabbath Rest – The Great Seventh Day

7,000 years from the creation of Adam

6,000 years from entrance of sin to world-wide establishment of Christ's Kingdom

6,000 years of man's right of rulership

Sixth Creation Day

The Great Pyramid 187

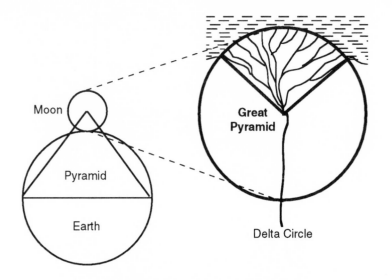

Moon

Pyramid

Earth

Great
Pyramid

Delta Circle

The Delta Circle has a diameter of 216 miles, corresponding to the moon which has a diameter of 2160 miles. The precise proportions of the Great Pyramid can be traced on the centers of earth and moon. This puts the Topstone at the center of the moon. The actual dimensions are measured in miles, however, let's change the unit.

The word "moon" in the Greek New Testament is *selene*. It has a Gematria value of 301. Let's assign the diagonal (hypotenuse) of the Pyramid triangle 301 units. By doing this, the half-base becomes 186 units, and the height becomes 236.8 units. These figures can be obtained by trigonometry, using the famous Pyramid Angle of 51° 51'. Or, they can be obtained by the Pythagorean formula for a right triangle $a^2 + b^2 = c^2$. Amazingly, the relationship of the hypotenuse to the half-base is precisely the Golden Proportion.

```
301 Hypotenuse
x .618 Golden Proportion
186 Half-base
```

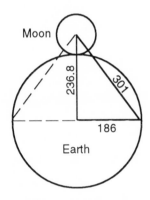

301 = Moon, σεληνη
301 = Calvary, κρανιον
186 = Golgotha, Γολγοθα
2368 = Jesus Christ, Ιησους Χριστος

This simple graphic reveals the awesome relationship of the Nile Delta to the earth and moon, and the position of the Great Pyramid at the head of the Delta. Yet, though simple, it displays the magnificent wisdom of God in the creation of these precise geographic/number relationships. There is no way it could have been contrived by man. It is evidence of a planned creation by a Master Mathematician.

Goro Adachi, in his book *The Time Rivers[1]*, makes the following observation:

> The present name for Egypt is *al Misri,* which ... can denote "drawing plan' or 'representation' – as if to say that Egypt is a country built according to a geometric plan. And anchoring this plan, of course, would be the Great Pyramid, a geometric and mathematical *magnum opus.*

The Great Pyramid sits at the center of the longest land parallel and meridian, equally dividing all four quadrants of earth's land mass. This is perhaps why it was once the location of the Prime Meridian of earth. At the time of the building of the Great Pyramid, longitudes were reckoned from this natural Prime Meridian (0/360°) running from pole to pole through the Pyramid's summit platform (prepared for the Topstone).

At an international conference in the United States in 1884, twenty five countries met to fix a standard world meridian. It was put to a vote, and Greenwich was chosen. Thus today's prime meridian on planet earth is considered to be the Royal Observatory Greenwich, in London, England. But geographically, and numerically, it is still the Topstone of the Great Pyramid – a Topstone that has not yet been placed.

King David prophesied it would yet become the *"head of the corner."*

1 Goro Adachi, *The Time Rivers,* p. 21

In the Living Parable, Dr. David Livingstone was a picture of Jesus Christ, the "living stone" that will be placed atop the Great Pyramid. The Apostle Peter had much to say about this glorious Topstone.

> *"... coming, as unto a living stone, disallowed indeed of men, but chosen of God, and precious.... Wherefore also it is contained in the scripture, Behold I lay in Sion a chief corner stone, elect, precious: and he that believeth on him shall not be confounded. Unto you therefore which believe he is precious: but unto them which be disobedient, the stone which the builders disallowed, the same is made the head of the corner..."* (I Peter 2:4-7)

The average height of earth's land mass, above sea level, is 5449 inches. The height of the Great Pyramid from its socket level base to its summit platform is 5449 Pyramid Inches. The Pyramid sits at sea level at the head of the Delta. Its 5449 Pyramid Inches of height brings it up to the resting place of the Topstone. It is as if it were the "gateway" into the Delta. And indeed it is.

It is only through the redemptive work of Jesus Christ that mankind will have access to the blessings of life represented by the green delta and its life-giving water. The Topstone is as if it were a prism, through which light enters and is defined into its rainbow of colors, healing man from the effects of sin, and bringing them back into the beautiful full light of divine favor that Adam enjoyed. The six colors in the spectrum represent the full restora-

tion of man back into relationship with their God, the source of light.

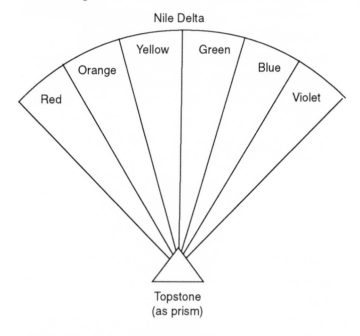

Topstone
(as prism)

The six colors of the spectrum of white light figuratively restore man to his original perfection, which was represented by the number 6. This was man's number before he fell. But 6 has been associated with fallen man, thus we think of 6 as the number of sin. In reality, it only takes on this number because man sinned. By the end of earth's great Millennium, all mankind will have been restored to the original perfection which Adam enjoyed; thus the number 6 will again represent man in perfection.

It is by means of the "prism" that the perfect six can be restored to man.

Isaiah wrote the beautiful words,

"Behold, a King shall reign in righteousness ... as rivers of water in a dry place, as the shadow of a great rock in a weary land."

Perhaps he was seeing far down into the timeline of man, and viewing the Nile as a river of life in a dry land, and the Great Pyramid as the *"great rock"* whose shadow (symbolism) will bring rest to a weary land.

King David rejoiced to see the hand of God in the deliverance of his forefathers when he wrote:

"He opened the rock, and the waters gushed out; they ran in the dry places like a river."

A river in a dry place. It is not nature's way. That is why, before the discovery of the source of the Nile, man wondered and marveled at this vast flowing river coming through a barren desert. Where did the water come from? In a land that receives no rain, the presence of such a copious river seemed not to be possible – yet there it was, bringing life to the desert.

"He clave the rocks in the wilderness, and gave them drink as out of the great depths. He brought streams also out of the rock, and caused waters to run down like rivers." (Psalm 78:16)

The life-giving blood of Jesus Christ is pictured by the Nile, as it flows down through the arid desert where there is no rain. It is man's only source of life. It was a promise that was unwritten in the mind of God long before the earth was created. It was the intention of the

Creator to have a human family that would live in peace, happiness and perfection in a perfect home.

He revealed this plan to Abraham when he promised *"In thee and in thy seed shall all the families of the earth be blessed."* That promised *"seed"* was none other than Jesus Christ. And it is through the giving of His innocent blood for the guilty blood of Adam that all mankind will have the opportunity to return to the possession of all that Adam had before he sinned.

This promise of life through Jesus Christ is beautifully pictured by the Nile, as it flows from the highlands of Uganda, and the highlands of Ethiopia, down into the Great Rift , bringing its life-giving waters to the thirsty desert. This is *The Promise Written in Sand.*

End Notes

1. (page 154) In an attempt to obtain the original text of the Ten Commandments it is good to refer to the text as written in the Targum of Onkelos. The work of Onkelos was specifically with the five books of Moses, and particularly with the Decalogue. He was an expert. He sought for the purity of the text, as it had originally been given to Moses. In doing so, he made two very minor changes, which do not change the meaning of the text, but it does change the Gematria. If the work of Onkelos has brought us back to the original text as it was given to Moses, then we could expect it would render the Gematria accurate and meaningful. (Please see *The Bible in Aramaic, The Pentateuch According to Targum Onkelos,* by Alexander Sperber.)

One of those changes occurs in the first Commandment, *"You shall have no other gods before me."* In the Masoretic Text the word "gods" is אלהים (Elohim), a plural word. Onkelos renders this word אלה (Eloh), a singular word. Thus the English translation would be *"You shall have no other god before me."* The meaning is the same, but by dropping the ים from the text, it reduces the Gematria by 50.

The second change is in the fourth Commandment, "Remember the Sabbath day by keeping it holy." The minor change that Onkelos records is simply the dropping of the Hebrew letter ה from the word "Sabbath." Putting this letter on the word "Sabbath" is called an

attachment. The letter ה when attached to the beginning of a word is the definite article *"the."* Thus Onkelos has rendered this as *"Sabbath"* whereas the Masoretic Text renders it *"the Sabbath."* The definite article has already been given its place in the sentence as it is written in Hebrew; thus attaching one to the word Sabbath is redundant. By dropping this extra ה it reduces the Gematria by 5. Thus, the two minor changes which Onkelos recorded, in an effort to be pure to the original text as was given to Moses, will reduce the Gematria of the Ten Commandments by 55.

These two minor changes do not alter the meaning of the text, but rather they render it more gramatically correct, both in English and in Hebrew. Because Onkelos was considered an expert on the books of Moses, and especially of the Ten Commandments, we can have a large measure of confidence in the accuracy of his text.

Other Books by Bonnie Gaunt

Genesis One

Apocalypse...and the Magnificent Sevens

Time and the Bible's Number Code

Jesus Christ: the Number of His Name

Stonehenge and the Great Pyramid

The Stones and the Scarlet Thread

The Bible's Awesome Number Code

The Coming of Jesus

Beginnings: the Sacred Design

Encoded into the first verse of the Bible are the awesome numbers through which all creation was generated.

This book reveals the exciting new discoveries of the Bible's hidden numbers that will transport you from our foundations in creation into the magnificent future that has been planned for man on planet earth. The amazing relationship of the book of Revelation to the first chapter of Genesis reveals a magnificent plan that was ordered from the beginning, and has progressed precisely on schedule through a circle of seven thousand years. The future of man has its roots in Genesis One.

GENESIS ONE

By Bonnie Gaunt

$14.95

Order from Adventures Unlimited Press

An Exciting New Look at an Amazing Prophecy!

The Book of Revelation is a marvelous display of the simplicity and beauty of the Bible's Number Code (Gematria). In fact, the application of the Number Code opens doors to the understanding of its prophecy, making the complicated simple, the feared an anticipation, and the outcome a magnificent joy.

Using a few simple guidelines, the Apocalypse unfolds its amazing prophecies of today's world. It's here! It's today! And we are living in it.

APOCALYPSE
...and the Magnificent Sevens

by Bonnie Gaunt

$14.95

Order from Adventures Unlimited Press

Where are we in time?

*An Exciting Book
for the
New Millennium,
Confirming our place in
God's Time-Line for Man.*

Time and the Bible's Number Code

by Bonnie Gaunt

The Patterns of the Number Code (Gematria) and the patterns of time, combine with the patterns of the Golden Proportion to tell God's magnificent story, and confirm our place, today, in His plan for man. $14.95

Jesus Christ
and the
Amazing Number Code
Found in the Bible!

Jesus Christ
the Number of His Name

by Bonnie Gaunt

The Bible's number code tells of the new Millennium and the Grand Octave of Time for man. It reveals the amazing relationship of the number code to the ELS code in the prophecies of the coming of Jesus. Explores the relationship of the Golden Proportion to the name and work of Jesus. $14.95

Additional Evidence from the Bible's Number Code, Stonehenge, and the Great Pyramid.

$14.95

The Stones and the Scarlet Thread
by Bonnie Gaunt

The Bible's Number Code reveals an amazing end-time confirmation of our faith in the redemptive power of the blood of Jesus Christ. This remarkable story has been revealed to us through the Word written, the Word in number, the Word in the cosmos, and the Word in stone. Evidence found in the measurement and construction of Stonehenge and the Great Pyramid confirm the beautiful story of the Scarlet Thread.

$14.95

The Bible's Awesome Number Code
by Bonnie Gaunt

The Number Code reveals that the parable of the Good Samaritan is, in fact, a time prophecy revealing the time of Jesus' return. His miracles of healing and of turning water into wine are also time prophecies. The Number Code takes us on a journey from Bethlehem to Golgotha, and into the Kingdom of Jesus Christ.

Additional Books About the Gematria Number Code of the Bible.

The Coming of Jesus
the Real Message
of the Bible Codes!

by Bonnie Gaunt

The constellations of the heavens are a picture code, telling the same story of the end-time as is found in the number code and the ELS code of the Bible.

$14.95

Beginnings
the Sacred Design

by Bonnie Gaunt

The Bible's Number Code reveals an amazing design woven into all creation – a design of which we are a part. From the atom to the solar system this design tells of a magnificent Creator who planned for eternity. The relationship of music to the Gematria of the Bible is shown in its simplicity. This book explores the "what," "when" and "how" of the origins of man, our earth, our solar system, and our universe.

$14.95

Order from Adventures Unlimited Press

One Adventure Place
P.O. Box 74
Kempton, Illinois 60946
United States of America
Tel.: 815-253-6390 • Fax: 815-253-6300
Email: auphq@frontiernet.net
http://www.adventuresunlimitedpress.com
or www.adventuresunlimited.nl

ORDERING INSTRUCTIONS

✓ Remit by USD$ Check, Money Order or Credit Card
✓ Visa, Master Card, Discover & AmEx Accepted
✓ Prices May Change Without Notice
✓ 10% Discount for 3 or more Items

SHIPPING CHARGES

United States

✓ Postal Book Rate { $3.00 First Item 50¢ Each Additional Item
✓ Priority Mail { $4.00 First Item $2.00 Each Additional Item
✓ UPS { $5.00 First Item $1.50 Each Additional Item
 NOTE: UPS Delivery Available to Mainland USA Only

Canada

✓ Postal Book Rate { $6.00 First Item $2.00 Each Additional Item
✓ Postal Air Mail { $8.00 First Item $2.50 Each Additional Item
✓ Personal Checks or Bank Drafts MUST BE
 USD$ and Drawn on a US Bank
✓ Canadian Postal Money Orders OK
✓ Payment MUST BE USD$

All Other Countries

✓ Surface Delivery { $10.00 First Item $4.00 Each Additional Item
✓ Postal Air Mail { $14.00 First Item $5.00 Each Additional Item
✓ Payment MUST BE USD$
✓ Checks and Money Orders MUST BE USD$
 and Drawn on a US Bank or branch.
✓ Add $5.00 for Air Mail Subscription to
 Future Adventures Unlimited Catalogs

SPECIAL NOTES

✓ RETAILERS: Standard Discounts Available
✓ BACKORDERS: We Backorder all Out-of-
 Stock Items Unless Otherwise Requested
✓ PRO FORMA INVOICES: Available on Request
✓ VIDEOS: NTSC Mode Only. Replacement only.
✓ For PAL mode videos contact our other offices:

		Please check: ☑		
☐ This is my first order		☐ I have ordered before		

Name				
Address				
City				
State/Province			Postal Code	
Country				
Phone day			Evening	
Fax				

Item Code	Item Description	Qty	Total

Please check: ☑

		Subtotal ➠	
	Less Discount-10% for 3 or more items ➠		
☐ Postal-Surface		Balance ➠	
☐ Postal-Air Mail (Priority in USA)	Illinois Residents 6.25% Sales Tax ➠		
		Previous Credit ➠	
☐ UPS		Shipping ➠	
(Mainland USA only)	Total (check/MO in USD$ only) ➠		

☐ Visa/MasterCard/Discover/Amex

Card Number	
Expiration Date	

10% Discount When You Order 3 or More Items!

Order From:

Adventures Unlimited Press, P.O. Box 74, Kempton, IL 60946, U.S.A.
Tel. 815-253-6390 FAX 815-253-6300
email: auphg@frontiernet.net
www.adventuresunlimitedpress.com